HIDDEN
HISTORY
of
BOSTON

HIDDEN
HISTORY
of
BOSTON

Dina Vargo

THE
History
PRESS

Published by The History Press
Charleston, SC
www.historypress.com

Front cover: Amelia Earhart outside the Denison House in Boston. *Courtesy of the Boston Public Library, Leslie Jones Collection.*
Back cover: *Courtesy of the Francis A. Countway Library of Medicine and the Creative Commons.*

First published 2018

Manufactured in the United States

ISBN 9781625858740

Library of Congress Control Number: 2018932094

For my snug, Malini—I couldn't have dreamed you up.

And for Henry and George Naismith and Alexis Meltzer—always make time to do something you love.

CONTENTS

Acknowledgements

The book is here! Allow me to break out the Cherry Bounce and raise a celebratory toast to all those who helped along the way. Let me start by thanking my partner, Malini Biswas, without whom I would be a crazy lady spitting out random history stories to strangers on the street. De facto editors Wicket and Rosie provided hours of comfort and occasional insight while cuddling up on my lap or beside the computer while I wrote.

Special thanks to the entire Boston By Foot organization, led by Samantha Nelson, Cortnee Bollard and Boston's best volunteer tour guides, for making the True Lies and False Facts Tour possible every year and, as such, creating the catalyst for this book. As always, thanks to my Graveyard Girls (and guy!) Judy Glock, Gretchen Grozier, Heather Pence, Margaret Bratschi and Paul LaShoto for their encouragement, story ideas and rogue visits into roadside burying grounds.

There would be no book without the resources provided by the Boston Public Library, which introduced me to the wide world of its online and oh, so easily accessible database of newspaper articles—what a treasure-trove! I'd also like to thank Jack Eckert, the Public Services librarian at the Center for the History of Medicine/Francis A. Countway Library of Medicine at Harvard, and Monica Shin, the Digital Projects librarian at the BPL. Special thanks to Bob Cullum, who permitted me use of the wonderful photographs taken by his grandfather Leslie Jones.

I'm also grateful to my acquisitions editor at The History Press, J. Banks Smither, for making this such a smooth and enjoyable experience.

Thanks, too, to my Front Street Crew—Michele Meltzer, Stephanie Cooper, Alison and Natalie Phelan, Michele Campbell, Chris Anderson, Karen Giroux, Denise Murphy, Beth O'Grady, Mara Mendelsohn and Shari Hewson—for being my cheering squad at local book talks.

Finally, this book really would not be possible without my friend and editor Sally Ebeling, who offered invaluable perception, probing questions, guidance and generally better words.

INTRODUCTION

If there's one thing that I've learned while writing and giving walking tours of Boston's history for the past ten years, it's that there's always still more to learn. It doesn't matter how many books I've read, how many lectures I've attended or how many tours I've taken; there's always something new to discover. Or, better yet, uncover.

I love what I call "offbeat" history—the stories that aren't often told, the B-side to the big hit, the less attractive brother or sister. The stories that, were they kids, would get picked last in gym. The underdog stories. You know how it goes—the B-side is a musical masterpiece, the ugly duckling is really charming and the kid who gets picked last turns into the team's secret weapon. You never see the underdog story coming, which makes it even better. And because it's less told, it feels more special.

Buried deep within the pages of history books and newspaper columns or even in the text of historical markers is where you find these stories. You just have to keep your eyes open for them. Of course, Boston is one of the most storied cities with one of the longest histories in the United States, making it much more likely to find some hidden gems. Some are shocking, some are revolting, some are inspiring. *Hidden History of Boston* has a bit of them all.

I started collecting oddball stories to create an annual special tour for Boston By Foot, the best walking tour nonprofit in Boston (don't take my word for it; book a tour!). True Lies and False Facts: A Questionable Tour of Boston is built on the old maxim "The truth is sometimes stranger than fiction," and every year around April Fool's Day, we explore

a different neighborhood by way of tales that may be true or may be false. Our tourees try to guess which are which, and there's never been a person who hasn't been stumped by at least one of the stories. Who would think that pious Puritan settlers in Boston banned the celebration of Christmas, while fully supporting a raucous annual parade that culminated in burning an effigy of the pope? Who would believe that before Amelia Earhart became a great aviator, she was a social worker at a local settlement house? Some stories are darker than others, like the murder of two innocent children by a psychopathic preteen. There are stories of tragedies, like the fatal plunge of a trolley car into Fort Point Channel, killing forty-six people; and of poor Susanna Geary, stuffed piece by piece in several suitcases. There are stories of uplift, like that of the Crafts, who escaped slavery in Georgia and built their lives anew with great support of the Boston Brahmins. And then there are the truly oddball stories like the so-called Zoo Shipwreck, which unleashed monkey mayhem in Salem, and that of William Mumler, who claimed he could take a photo of you with your favorite dearly departed aunt.

Whether your tastes run to murder and mayhem, to things that go bump in the night or to little-known stories of people who should be much better known (or should have known much better!), *Hidden History of Boston* will have something for you. And if you think you know everything about Boston's history, you might be surprised.

Chapter 1

Do They Know It's Christmas?

The Banning of Christmas, 1659

Samuel Breck sat down to recount how Christmas was celebrated in Boston during his boyhood years, back around 1780. He came from an upper-crust family, and while his family was having a gathering, playing cards and chatting together, a group from the meanest class forced their way into his home. He described them as "disguised in filthy clothes and oftimes with masked faces"; the band of misfits demanded everyone's attention by joining the card game, sitting on the furniture and generally making a nuisance of themselves. The only way to get rid of them was to give them some cash: "Ladies and gentlemen sitting by the fire. Put your hands in your pockets and give us our desire!"

Still not satisfied, the devilish crew then staged an impromptu play, acting out the death and revival of a reveler, right there in the midst of what had been a lovely evening for Breck and his friends. After about a half hour, the troupe disappeared, only for another group to come along and take their place, acting out a similar series of comic scenes and taking leave with a few coins.

A classic straight out of a Currier and Ives print this is not! Instead of a snowy sleigh ride and carols around a decorated tree, the Breck family holiday party was broken up by a ratty troupe of ruffians who disrupted their gathering, put on a play and then beat it out the back door with a mouthful of treats and a pocketful of the family silver, all before another merry gang came along to do it all over again.

This is not your typical idea of how early New Englanders enjoyed Christmas, but this kind of "celebration" is exactly why the Puritans banned it in the first place.

Puritans had a tense relationship with Christmas. As far as they were concerned, the exact date of the birth of Christ had never been determined, let alone confirmed. If Christ had been born on December 25, why wasn't it written anywhere? The Puritans knew the Bible back and forth, and the date of December 25 is nowhere to be found. The Puritans knew the truth of the matter—as Christianity was emerging as a more widely accepted and practiced religion, church leaders also struggled to find the date of Christ's birth. That led them to co-opt a popular pagan festival called Saturnalia. Call it killing two birds with one stone—undermine a pagan holiday and establish a Christian holy day. Celebrated at the Winter Solstice, at the end of harvest season and the start of a long, dark winter, Saturnalia was something of a bacchanal, a sort of spring break many months early.

During ancient Roman times, Saturnalia started on December 17 and continued until the twenty-third. During that period, gifts were given, feasts were attended and people were free to gamble and play dice games. The period was also marked by role reversals—slaves were allowed to eat with their masters, men dressed as women and vice versa. A Lord of Misrule was appointed to oversee the shenanigans, and obviously, no small amount of alcohol was consumed. "Moral excess" was the rule of the day, and it was not coincidental that a lot of babies were born nine months later.

Another tradition was also carried on. Akin to role reversals, the Saturnalia season, and later the Christmas season, was a time in which those with money helped the poor, so long as the poor literally sang for their supper. The singing was called "wassailing" or caroling. Mainly taken on by young boys, a group of kids would enter into a rich person's home to sing for them and afterward be rewarded with food and money.

Even after Christians adopted Saturnalia as their own and called it Christmas, the rowdy traditions lived on all over Europe and in England. A pagan holiday called by any other name is still a pagan holiday, which is why the Puritans refused to observe it. And there was yet another reason why the Puritans rejected it—too much chaos, too much confusion and too much fun! In both England and New England, the Puritans were driven to purify the church, not pump up the volume. They removed all decoration from their churches and called them meetinghouses. They tried to control as much of their environment as possible and valued hard work, piety, learning and clean living. Before banning Christmas entirely, they tried to make it a fast

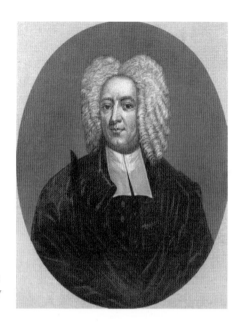

Cotton Mather was no fan of fun and frivolity. *The Miriam and Ira D. Wallach Division of Art, Prints and Photographs: Print Collection, The New York Public Library.* *"Cotton Mather, D.D."* The New York Public Library Digital Collections, *1777–1890.*

day. We all know how that worked out long term, but the Puritans' rejection of Christmas did affect those early American Christmases for much longer than the twenty-two years the holiday was actually illegal in Massachusetts.

How did the Puritans celebrate Christmas? They didn't. If Christ's birth couldn't be proven, there was truly nothing to celebrate. Work went on as usual, shops and stores stayed open, there were no special services, no meetinghouse bells ringing, no wreaths hung on doors or candles in windows. In New England, Christmas was just like any other day. It was those darned non-Puritans who ruined the party…by having a party.

The raucous traditions of Christmas traveled across the Atlantic to the colonies as more Anglicans made their way to New England. Caroling and singing in the streets, gambling, eating to excess, drinking, public drunkenness and the sexual conduct that accompanies all of the above were completely unacceptable behavior to the Puritans. To combat the revelry, in 1659, they took a page out of their brothers' rule book in England (which had abolished the observance of Christmas in 1647) and banned the holiday. The ban must not have had the desired effect. Increase Mather wrote in 1687, "Men dishonor Christ more in the twelve days of Christmas then in all the twelve months besides."

The ban was enforced with a five-shilling fine. It was accompanied by another law against taking any time off work to celebrate the holiday. No feasts were to be eaten, no carols sung, no playing of games and, clearly, no

heavy drinking allowed. In a statement that seems to be reiterated by cultural pundits or Charlie Brown wondering about the true meaning of Christmas, Cotton Mather asked in 1712, "Can you in your conscience think that our holy savior is honored by mirth, by long eating, by hard drinking, by lewd gaming, by rude reveling…"

This ban against Christmas was in many ways more than what met the eye. The ban coincided with tension with England over the control of the Massachusetts Bay Colony. One could say that the ban of Christmas was an early shot across the bow of Britain in the long move toward independence. Indeed, in 1665, Charles II demanded that the ban on Christmas be lifted in New England to bring the colony more in line with British customs and traditions; Britain had abolished the ban in 1660. The ban was finally rescinded in 1681 under pressure from the Crown, but that did not mean that the Puritans started to observe Christmas.

There was an ongoing battle between the hated Governor Edward Andros, an Anglican appointed by the king, and the Puritans. Andros insisted on closing businesses on Christmas Day during his reign from 1686 to 1689. Later, as more Anglicans continued to arrive in Boston, it was something of a battle of wills to keep shops open on Christmas Day. The governors asked that leaders of the clergy encourage their parishioners to close shops, and both Cotton Mather and Samuel Sewall were among those who rejected the request. This was one way that the colonists could keep control over their day-to-day life under British rule.

The Reverend Samuel Sewell especially had a bone to pick against Christmas, writing constantly in his diary of those sinners who celebrated the holiday and how they did so. Whether it was a small French congregation or a newly ordained Anglican minister in Braintree, he observed and documented the transgressions.

Many years later, after the ban had been rescinded and Christmas was no more acceptable, the practice of mumming was taken up in Boston. Harkening back to the uproarious traditions of Saturnalia, mummers would disguise themselves and visit the homes of the well-to-do. "Visiting" might actually be too polite a term; mummers would barge into homes and make a nuisance of themselves. They would put on a short play and make a request of food or money. Those who participated were usually poor, and they cleverly called themselves the Anticks. From the 1760s into the 1790s, Boston's finest families, like the Brecks, might entertain a visit from multiple groups of Anticks in the same night. At the time, tradition held that the well-to-do had to accommodate the groups of merrymakers, but later, these fine families

started to complain and make their complaints public in the newspapers. Because of the outcry, police suggested that community members be free to make civilian arrests, after which the practice of mumming faded away.

By 1800, New England Unitarians had made their own play to subvert the pagan aspects of Christmas by making it an acceptable Christian holiday. Perhaps if it were a more respectable holiday, with the added sweetener of a day off work, people could be convinced to attend church to celebrate the birth of Christ and turn their back on the more crass aspects of the holiday. In 1817, a handful of Unitarian churches attempted to hold Christmas services and partnered with local businesses to close their doors, but by 1828, it was back to business as usual in Boston. Stores were open for business, and church doors were closed.

Again, we know how this story ends. Christmas is one of the most looked-forward-to Christian holidays that is often celebrated in some way by one and all, regardless of faith. Whether it's the office holiday party (and Yankee Swap), just enjoying the Grinch on television or the music that becomes ubiquitous after Thanksgiving Day, Christmas season has become inescapable. And after all that the early New Englanders did to stop the celebration of Christmas in its sleigh-ride tracks, one of the cultural touchstones that popularized Christmas and made it much more accessible to families across America was developed by none other than a Bostonian. That touchstone is the giving and receiving of Christmas cards.

An extension of the traditional calling card, the holiday card was invented in England in 1843. By the 1850s, Christmas cards were being shared in America. A printer named Louis Prang, a German immigrant, seized upon the idea and turned a simple card into a huge industry. A postal official called it "Christmas card mania."

Prang arrived in Boston in 1850. A wood engraver by trade, he worked for several printing presses until going off on his own in 1860. By 1868, Louis Prang & Company owned close to half of all steam presses in America. He was one of the best in the business, committed to using new technologies for better quality cards. He prided himself on introducing fine art to the American public in an affordable way. While other printers also sold Christmas cards, it was Prang who turned it into a massive enterprise. His cards were bigger and more "Christmas-y" than the cards created by his early contemporaries.

Prior to Prang's involvement, Christmas card designs were Victorian in nature but lacked most indications we now associate with the holidays. The cards would feature flowers, children and birds. All lovely, to be

A Louis Prang Christmas card. *L. Prang & Co.*, Christmas, *1862.*

sure, but it took Prang and his stable of (mostly female) artists to create the lexicon of the season—sleigh rides, evergreens and holly berries, carolers, families by the fireside, snowy churches and angels. Some of his most popular cards were fringed in silk, and overall, his cards were bigger and thicker than his competitors'. In this way, his cards could be offered as gifts in and of themselves. Indeed, Christmas cards didn't wind up in the trash bin as quickly as they do today. Often the cards would be framed and hung in the home as artwork—such was both the sentiment and the quality of Prang's product.

Of course, the overwhelming popularity of Christmas cards enabled other printers to enter the game and produce their own, with much less of a commitment to fine art and quality production and a stronger commitment to the bottom line. Prang, often hailed as the Father of the Christmas Card, continued on in his print company, producing fine art for public consumption, but eventually got out of the Christmas card business. Prang is buried in Forest Hills Cemetery, not too far from his factory in Jamaica Plain.

Chapter 2

An Audience with the Pope

Pope's Night Celebrations, circa 1685–1774

John Poole hurried home. The sun had just set, and the chill November air spurred him to put some pep in his step. He usually enjoyed such evenings, breathing in the autumn air before the snow started to fly, but tonight, he wanted to get home, preferably behind locked doors. Trouble was brewing, as it had on this night every year since he could remember. He was all the more anxious because the violence was worsening. It used to be a bunch of street toughs battling it out for neighborhood turf, all in the name of good fun. Lately though, the fun had turned deadly. Just last year, a young boy was killed under the wheels of the North End mob's cart, and the brawl had lasted all night long. Every year, the same ritual played out on the streets of Boston. The enemy wasn't the rival street gangs; they were united against their common devil, the old Whore of Babylon. A fiery death for him was an issue on which almost all Bostonians could certainly agree.

Poole didn't begrudge the fellas their fun, but he'd rather avoid a run-in. He'd done what he could to stay on the right side of the mob by donating a cask of rum for their festivities. Hopefully, they'd remember his deed and leave him and his family alone.

Poole continued his speedy cruise from the Long Wharf to home, but he could already see a crowd starting to gather—a drunken throng pushing and shoving at one another. He saw one member of the group point, and the horde gasped as they looked toward the North End. The procession had started. As he rounded the corner to get home, he could see the cart approaching with the most resplendent, beautifully decorated figure sitting

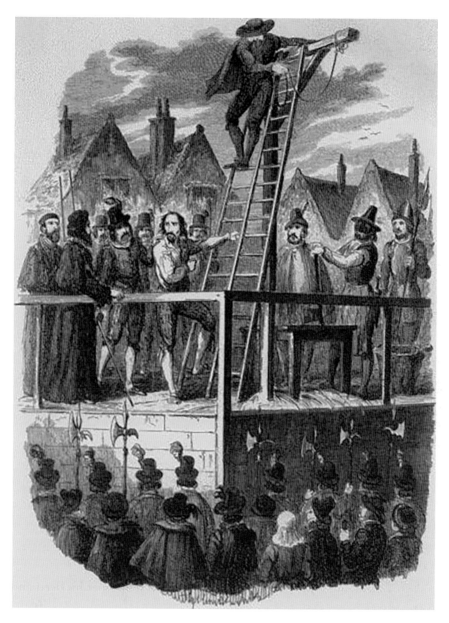

The brutal execution of Guy Fawkes. Made by George Cruikshank (1792–1878) in 1840 for a book titled *Guy Fawkes or The Gunpowder Treason* by author William Harrison Ainsworth.

atop it. Its robes flowed, caught in the evening breeze; its face was illuminated by the men carrying torches beside it. It wore a tall cap, decorated with bits of glass and ribbon that flickered in the night. Flanked by the horrible effigy of the horned Devil, which appeared to be dancing a jig, the crowd appreciated the artistry that had gone into making the dummy. Its twin, making its way to the center of town from the South End, was equally resplendent and terrible. Both would be consumed by bonfires by the end of the night—that was the way the Pope always ended his journey across Boston on the evening of November 5.

Pope's Night (also called Pope's Day) was an annual celebration of anti-Catholic hatred. Celebrated every November 5 from roughly 1685 to 1774, the holiday had roots in Britain's Guy Fawkes Night celebrations. Guy Fawkes was a Catholic who famously plotted to assassinate King James I by blowing up Parliament via a stockpile of gunpowder in its basement. He and his co-conspirators were caught on November 5, 1605. When they were found out, they were tortured to extract a confession to the so-called Gunpowder Plot. They were punished for treason by hanging to "near death." As if that wasn't enough, they were then "drawn and quartered," meaning that each of their limbs and head was hacked off. Sometimes each limb would be attached to a different horse, and you can imagine the spectacle when each ran in a different direction. Occasionally, a little disembowelment and emasculation might be thrown in for fun, as the victims watched their own entrails be thrown into a raging fire—if they were conscious. Fawkes actually avoided this fate, succumbing to a much more humiliating one. He fell off the hangman's scaffolding and broke his neck. Lucky break?

Meanwhile, across the pond, the holiday was especially popular in Boston because its citizens were particularly intolerant of Catholics and other religious groups in the colonial era compared to those in the other colonies. Why was this? Bostonians were Puritans, a religious group that wanted to go further than King Henry VIII had when he broke from the Catholic Church to found the Church of England. Puritans, both those in England and New England, are so named because their aim was to "purify" the Church of England—to make it more Protestant, less Catholic. Even today, some consider the Church of England to be "Catholic lite." The Pilgrims, the group famous for the *Mayflower*, Thanksgiving and Plymouth Rock, wanted to go a step further and break away entirely from the Church of England. They were considered "Separatists." It was the constant internal strife and battle for control for the English Crown between Protestants and Catholics that spurred the Pilgrims and Puritans to come to the New World. While they

came to practice their faith without the constant threat of recrimination, this did not translate to freedom for all religions. In fact, it was very much the opposite. Only Puritans were welcome in the Massachusetts Bay Colony. Quakers, Jews and, in particular, Catholics were not at all welcome.

To that end, all Catholic priests were banished from Massachusetts in 1647, and practicing Catholics were not allowed to worship publicly until 1780. Bostonians were a narrow-minded bunch when it came to religion—so intolerant that even two Puritans, Anne Hutchinson and Roger Williams, were thrown out of the colony for thinking a little outside the Puritan box. So while Pope's Night was celebrated in England (as Guy Fawkes Day) and its North American colonies, Pope's Night took on a life of its own in Boston.

The working-class men of Boston were the main actors in Pope's Night celebrations. Catholic or not, a bit of ritual was involved. The event unfolded in the same way every year. Two competing street gangs—one from the North End and the other from the South End—built carts, essentially parade floats, and adorned them with effigies of the Pope, the Devil and at times other unpopular political figures of the day. Sometimes the effigies were puppets animated by children, adding to the scene.

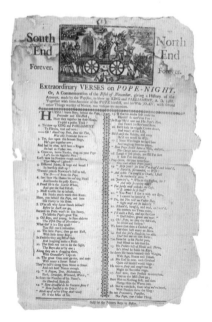

The costumed revelers spent the day imbibing copious amounts of rum and, by nightfall, were ready to rumble. Each gang, sporting clubs and torches, marched alongside its carts to a bonfire. Young boys followed along playing flutes and drums. At the fire, a huge street fight would ensue with the purpose of knocking the other's Pope into the fire first. On their way to the bonfire, the drunken men ran amok, bouncing from home to home collecting favors from their frightened inhabitants and using threats of vandalism or worse if the owners didn't comply. Very often, those who had the means left town every November 5

Woodcut and headline from a broadside titled *Extraordinary Verses on Pope-Night* showing the traditional cart with a seated pope and the devil standing behind him. *An American Time Capsule, American Memory Collection, Library of Congress.*

and wrote letters to the local papers complaining about the "common" men being completely out of control.

In Britain, Charles II ordered that November 5 be declared an official holiday to ensure it be celebrated at home and throughout all the British colonies, including North America. The first recorded celebration of Pope's Day in Boston was in 1685, not coincidentally the same year the Catholic James I took the throne in England. In the early days, the celebration was rowdy but a bit more contained than what it would become. Crowds at first would meet at the bonfire and drink, but by 1745, the holiday was edging beyond control. The town council tried to wrest some authority over it by passing the literal Riot Act of 1755, but nothing could contain its popularity and violence.

In the run-up to the Revolutionary War, Pope's Night became even more outrageous as it served as an extension of the riots and mob actions put into play to protest the Stamp Act and other British affronts. At that time, Pope's Night became a sort of testing ground for organizing the mobs used in the Stamp Act riots. In one instance, a group of merchants covertly recruited Ebenezer Mackintosh, a shoemaker and leader of the South End gang in the 1760s, to lead the same mob against customs officials and other Loyalists. The mob actions were incredibly effective in "protesting" the Stamp Act by means that would seem uncivilized today—hanging Loyalists in effigy before marching across town, ransacking their homes, protesting outside of their businesses and assaulting them physically on the streets. The same energy and rancor against the pope was harnessed in a very ugly way to make a stand against the British. It's hard to miss the irony that the British enforced such a vulgar "holiday" only to have the people and tactic used against them almost one hundred years later.

The holiday was last celebrated in 1774. George Washington came to town in 1775 to lead the Continental army, which was stationed in Cambridge. When he caught a whiff of his men's desire to observe Pope's Night, he put a stop to it immediately, calling the celebration "ridiculous and childish." The general knew that one way to increase the colonists' chances of winning the Revolutionary War was to make an alliance with France and French Canada, which were largely Catholic. After that time, Pope's Night was celebrated only a handful of times in Boston, without quite the vigor from previous years. That certainly didn't mean that Bostonians were more accepting of Catholics in the years to come. Far from it.

Chapter 3

NIGHT SHIFT

Body Snatching in Boston, circa 1800

John Collins Warren was out for the night on a clandestine mission. He met up with a few of his college friends, also medical students at Harvard. It was around ten o'clock when the group met at their predetermined spot and steeled themselves for what they were about to do. Outfitted with picks and shovels, moving quickly and quietly, they breached the walls of the North Burying Ground (today known as Copp's Hill) and got to work. The moonlit sky was bright and clear, so a leisurely pace was not an option.

One of their friends had been given a tip—a man with no relatives in Boston had just been buried at the North Burying Ground. This man would make for the perfect specimen for their studies. They just had to dig him out of his grave first.

They approached the marked grave, freshly dug, and started in. Nervous, they were convinced they'd made a mistake when they didn't find what they were looking for quickly enough and tried digging at another grave. When that spot was clearly wrong, they came back to their original location and started anew, with perhaps a bit more desperation; they'd just wasted precious time and were fearful of being caught. Finally, they broke through the casket and found their prize—a "stout young man."

Carefully and noiselessly, they hoisted the body out of its coffin and shoved it in a bag. With their heavy cargo secured, they made their way back to the burying ground wall. With much effort, they began to heave their new best friend over and then stopped dead in their tracks. They heard the shuffling

of footsteps on the cobblestoned way—a man was coming toward them, enjoying a smoke in the night air. Quick! Create a diversion!

Thinking fast, one student exited the burying ground and began to amble and weave as if drunk toward the smoking man. He started to argue with the fella when another of the grave diggers pretended to come upon them and inserted himself into the argument. He was able to lead the smoker off in the opposite direction, ensuring that John Collins Warren and the remaining crew had a moment to load their quarry into an awaiting coach and travel back to Cambridge.

Warren stayed behind with another young man, and the two began to fill the abandoned grave, but before long his companion apparently had enough excitement for the evening and high-tailed it home. Warren finished the job himself; he needed to cover his tracks carefully and eradicate any trace of their covert nighttime activity. They could not afford to tip off any visitors in the coming days, and no one could know that they were leaving behind an empty grave. After nervously assessing his handiwork, Warren loaded his tools into another getaway coach and returned to Cambridge.

The next day at school, the young men gathered around their ill-begotten cadaver. Their professor, the great Dr. John Warren, founder of the very school they were attending, surgeon for the Continental army during the Revolutionary War and father of John Collins, was alarmed and displeased by his son's actions the previous night. But when he laid his eyes on their nocturnal catch, all was forgiven. He admitted that the cadaver was a fine one, and he should know, since he and his more famous brother, Dr. Joseph Warren, had belonged to a secret society of body snatchers in their youth. The apple did not fall far from the tree. The elder Warrens' society was called the Spunkers, and the name is believed to come from a Scottish term, used in a Robert Burns poem, to describe a will-o'-the-wisp—a fantastical creature that could evade detection and was seen only by travelers at night.

Today, Boston is known as a center for excellence in science and medicine, but those groundbreaking doctors of the late eighteenth and early nineteenth centuries had to literally break ground to properly study anatomy, a key component to understanding how the human body works. But human dissection was largely illegal in those days. These days, dissecting a human cadaver is a routine part of the schooling of medical students, but in Warren's time, procuring a cadaver for one's individual study was an enterprise in and of itself. And as more medical schools started to open, more bodies were needed—demand far exceeded supply. Of necessity, the body-snatching business was born.

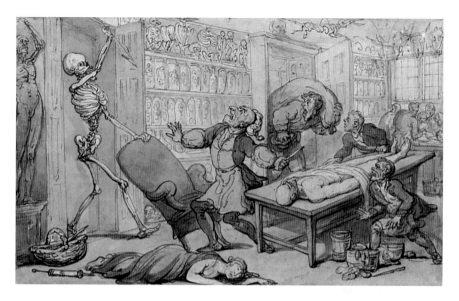

A perfect example of the prevailing attitudes toward anatomists in the early nineteenth century. *Spencer Collection, The New York Public Library. "Death in the dissecting room."* The New York Public Library Digital Collections, *1815–1816.*

Why was dissection, especially as a means to study human anatomy, illegal? For years, dissection was considered part of the punishment of being executed. It might not be enough to just hang a person for a crime; a judge might also determine that the crime was so great that the criminal should be opened up and undergo the indignity of being studied. People also believed in the concept of the "good death"—to die peacefully at home, among family, with a clear conscience. That did not include having your body torn asunder for the benefit of science. In order to gain entry into heaven, it was best to hedge your bets and turn up whole.

But dissection was necessary for learning, so medical students and medical schools had to resort to some unsavory behavior to round up cadavers to study. John Collins Warren admitted that his father, while army surgeon during the Revolutionary War, was able to get his hands on a steady stream of unfortunate "subjects" because he had access to the bodies of soldiers who had no relations claiming their remains. After peace was settled between America and Great Britain, that stream dried up. Hence, Warren's nighttime foray at Copp's Hill.

Dissection was so frowned upon that some reverse logic was employed in trying to stop body snatching. In 1784, a law was passed that outlawed dueling. This was more about stopping surgeons from dissecting the men on

the wrong side of the duel than stopping the duelers themselves. If a man was killed in a duel, his body could be transferred to a surgeon for dissection or be buried near a public highway with a stake firmly placed through his chest. Choices, choices!

Not only were bodies in short supply, but embalming techniques were also not perfected for years. Keeping a body fresh for a prolonged period of time—especially during the summer months—was difficult, if not impossible. A constant source of fresh bodies was all the more needed.

There was only one legal way to get a cadaver. Executed criminals and unclaimed cadavers were fair game for an anatomist, but they were hard to come by—maybe only one or two per year. For the criminals, a judge needed to intervene to assign a soon-to-be-cadaver to a surgeon. Sometimes a surgeon would strike a deal with a person on death row: "I'll pay you now for your dead body later." The situation was so desperate that surgeons in Britain were known to use their own deceased family members. The family that flays together stays together!

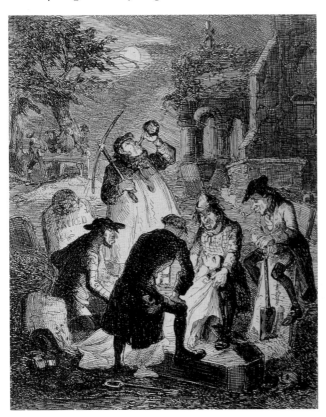

Illustration of resurrection men at work from a book published in 1887. *Courtesy of the Creative Commons.*

How to get dem bones? Outsource! The best and most certain route to a cadaver was to hire a body snatcher, also known as a Resurrection Man. A point of clarification—body snatching and grave robbing were two totally separate things. Body snatchers were after the body only. Grave robbers robbed a grave of jewelry, heirlooms and items of personal worth. No one really has the high ground here, but in a head-scratching legal twist, it actually wasn't illegal to steal bodies from graves; dissecting the bodies was illegal. It *was* illegal to steal personal effects from graves, so body snatchers would carefully remove the clothes and jewelry from a cadaver before loading it unceremoniously into a bag or crate. Body snatching, after all, was all about science and not about personal gain. Well, unless you're talking about two Scottish men working in Edinburgh—a hotbed of body snatching.

William Burke and William Hare had heard about how much money they could make digging up bodies for surgeons, but they decided to skip the digging up part and killed people instead. It was the perfect set-up. Hare and his wife ran an inn in the downtrodden Tanner's Circle neighborhood of Edinburgh. If a boarder didn't pay his bill on time, he paid in another way—when Burke and Hare collected their fee for his dead body. Anyone who passed through the inn was up for grabs, and they were certain to make it look like the death was natural. A pillow over the face was the weapon of choice. When they were found out, they confessed to killing, and being paid for, sixteen people. Hare gave up the ghost and was granted immunity. Burke's punishment? To be executed by hanging and then publicly dissected, of course.

Body snatchers were often grave diggers or church sextons, since both would have the inside scoop on who was being buried when and where and what their familial situation was. Grave diggers could have a nice gig going, being paid once to bury and then again to unbury a body. A skilled grave digger could exhume a body in fifteen minutes flat, and the professional skill set for a body snatcher included being both speedy and quiet to avoid detection. They even used special wooden tools to avoid the sound of clanging metal. In that same vein, they would pile the dirt on a sheet beside the grave to avoid getting fresh dirt on the untouched grass. They were economical in digging, concentrating on the top half of the grave to get to the head and upper body. Down to the coffin they'd dig, break open the lid and then insert two hooks under the arms of the cadaver and pull it out. After the clothing and effects were removed, the body was carted off in a canvas sack or meticulously packed into crates or even tea chests.

A body snatcher could catch a break after an epidemic. Not only were more bodies available, but mass graves were hastily dug, making it much easier and less time-consuming to raise the dead.

The business of body snatching got to be so prolific in America that writer Ambrose Bierce observed that graves were "a place in which the dead are laid to await the coming of the medical student." And indeed, medical students would often be required to scare up their own cadaver for class. Again, we look to John Collins Warren, man about marble town. At this point, Warren was a professor at Harvard Medical School and requested that two of his students round up a body for their classwork. (Warren was clearly done doing his own dirty work.) At a burying ground near the Boston Neck, his students marked a freshly dug grave of a former resident of the almshouse, believing they could be assured that this person had no family or relations to care to watch his grave. They came back that night, hauled the body onto a wagon and were almost immediately set upon by a group of self-appointed watchmen. A chase ensued; one of the students escaped in the wagon and rode aimlessly around the countryside, biding his time to come back to Boston, while the other was pursued on foot through the streets of Boston and Beacon Hill. The young man in the cart delivered the cadaver to class, while the other student, worn down by the stress of having thwarted his captors, contracted pneumonia and died shortly thereafter. While Warren felt bad about a potential bright life cut short, there's no word on whether the student continued to contribute to illuminating the learning at Harvard in other ways.

At one point, body snatching became so commonplace that people hired watchmen to keep an eye on a family member's grave until decomposition was given time to do its work. Enterprising companies sought to fill this new market of fearful families. A Columbus, Ohio company started to build a Torpedo Coffin with pipe bombs attached to it. If tampered with, it exploded. (Along with the body—an unfortunate afterthought.) Mortsafes were used primarily in Scotland (no wonder; it was the home of Burke and Hare). A mortsafe worked like a heavy-duty cage laid out on top of a grave that could only be accessed through a series of locked panels.

Slowly, over time, studying anatomy by studying cadavers became acceptable, in small part because of John Collins Warren's work. In 1831, Warren spearheaded an effort to legalize (and ultimately legitimize) anatomical study and autopsy. Massachusetts became the first state to legalize dissection with its Anatomy Act.

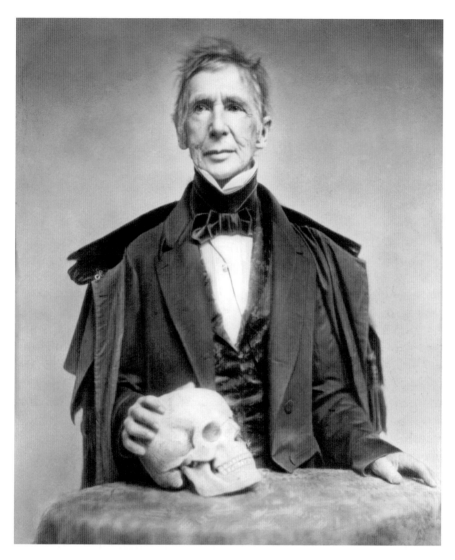

Portrait of John Collins Warren. *Courtesy of the Francis A. Countway Library of Medicine.*

Indeed, after stories of Warren's midnight exploits and the exploits of his students, he would go on to become one of the most prominent physicians in Massachusetts. Following in his father's footsteps, he was one of the founders of the *New England Journal of Medicine*, the first dean of the Harvard Medical School, a founder of Massachusetts General Hospital and one of the first doctors to risk performing surgery with a patient under anesthesia. He

also ensured the creation of Harvard's Warren Anatomical Museum with a monetary gift and specimens he collected throughout the years. Perhaps most fittingly, at his death in 1856, he donated his own skeleton to be "placed in the lecture room of the Medical College, near my bust."

Chapter 4

Burn, Baby, Burn

The Burning of the Ursuline Convent, 1834

The men congratulated themselves, slapping one another on the backs, yelling "Huzzah!" as the flames grew higher, magnifying the heat on this already warm August evening. One of them started to sing a rousing song, and the rest joined in, proud of their night's labor. Their work was tiring, and after a few hours of both physical and emotional exertion, some rested on the grass, enjoying the sight of the burning building, as others smoked cigars and shared cheese and crackers. It was a party atmosphere; the night had been extremely satisfying. Their plan had been in the works for a few weeks and had gone off without a hitch—no one had gotten hurt, and their effort was a huge success. They'd burned that rotten convent to the ground and run off the nuns to who knows where. The empty building crumbled as the men abandoned their bonfires and made their way back to their homes in surrounding Charlestown and across the bridge to Boston. For years, the charred remains on top of Mount Benedict would serve as a pointed reminder that Catholics were not welcome in Boston.

After the Revolutionary War, Bostonians became ever so slightly accepting of Catholics in their midst, if you can call it that. Prior to the Revolution, both John and cousin Samuel Adams spoke out against Catholics, saying they were "incompatible" with democracy. But the fact is that working with Catholic France and French Canadians was one of the keys to winning the Revolutionary War. Freedom of all religious denominations was granted in the new state constitution in 1779; the constitution of 1772 deliberately granted freedom of conscience to all *but* Catholics. This was progress but

in name only—the so-called small print revealed language that blocked Catholics from the possibility of ever holding elected office or having any real authority in government.

Despite this overt rejection, a small but growing number of Catholics decided to call Boston home and in 1788 established the first Catholic church on School Street. They practiced their first public Mass in Boston on November 2, 1788 (coincidentally, only three days before the traditional but by then obsolete anti-Catholic celebration of Pope's Night).

By 1799, there were one thousand Catholics in Boston, mainly of Irish descent. The prominent architect Charles Bulfinch was hired to build a new church for the growing congregation, and the Church of the Holy Cross was finished in 1803. (It is no longer there. The only church built by Charles Bulfinch remaining in Boston is St. Stephen's Church, on Hanover Street in the North End neighborhood.) Over the next few years, the Catholic Church continued to grow; in 1836, two new churches were consecrated to accommodate the number of Irish Catholic immigrants who were arriving at a steady clip. The Bulfinch church was demolished about 1862 and eventually replaced because of the need for a larger structure that remains as the Cathedral of the Holy Cross in Boston's South End.

And there's the rub—Protestant Bostonians and Irish Catholics could get along only when the Catholics were a very small minority. Starting in the 1820s, more and more Catholics were forced to leave Ireland to find a better life in America. There were two thousand Catholics in Boston in 1820, five thousand in 1825 and by 1830, more than seven thousand. The velocity of growth made not only Bostonians uncomfortable but Protestants all over the country very anxious.

The working classes, thinking practically, were concerned that their jobs were at risk, filled instead by the newcomers who were desperate enough to accept a lower wage. Protestant natives were also suspicious that the invading Irish Catholics were coming to America for much more insidious reasons—nothing less than a plot to hand over the United States to papal control. Old prejudices reemerged, and a cottage industry fueled by hate and innuendo was created. A new crop of newspapers was published to spread an anti-Catholic message. Newspapers like the *Protestant*, the *New York Observer* and, locally, the *Boston Recorder* and the *Christian Watchman* concocted completely false accounts of Catholic practices and plots to scare an anxious public. Likewise, preachers took to their pulpits to attack the Catholic church and to describe its "cruel" and subversive schemes.

What Protestants really couldn't wrap their heads around was the establishment of convents. What could possibly be more bizarre and rife with the possibility of misdeeds than whatever was going on behind the closed doors of these mysterious convents? Convents became a popular target of a burgeoning pulp fiction industry. Published as tell-alls, these books proclaimed to describe what *really* happened behind the closed doors of convents—tales of nuns and priests engaging in perverted acts; where nuns had babies who were quickly baptized, murdered and buried in basements shortly after their births; and where misbehaving nuns were chained up and left for dead. According to these accounts, having your knuckles smacked with a ruler was the least of anyone's concerns. Of course, none of it was true, but that didn't stop a hungry public from eating it up.

The best-selling novel at the time was a pot-boiler called *Awful Disclosures* written by Maria Monk, a supposed convent escapee. A Bostonian, Rebecca Reed, also tried her hand at the genre, publishing *Six Months in a Convent*. In it, she described the trials she faced at the hands of the nuns in a local Ursuline convent in Charlestown.

In an unfortunate perfect storm of events, an actual resident of Charlestown's Ursuline Convent named Elizabeth Harrison did "wander away" from the convent, roaming the streets of Boston for a few hours in a confused state. This event was very alarming to the people of Boston— apparently, the stories that were circulating in newspapers, books and sermons must have been true! They needed no further proof—the ugly acts they'd been hearing about were happening in their own backyard!

The reality was something entirely different, of course. When the Ursuline Convent was built in Charlestown (now in a part of Somerville), it was established in part as an educational institution for young women and girls. As it turned out, many liberal-leaning Protestant families, less interested in the vitriol and ire being stirred up around Catholics, were drawn to the convent to send their girls; it was a way to get a European-style education at a decent price. For the Catholic diocese, establishing a convent was a way to expand their influence in Boston without proselytizing.

Bostonians should not have been so quick to draw conclusions about the goings-on at the convent. Elizabeth Harrison had suffered a nervous breakdown and, after a few days of rest, returned to the convent under her own power. That would not, however, be enough for the concerned population of Boston. They needed to act. Solidifying their resolve were the words heard in a recent series of lectures by the Reverend Lyman Beecher,

who had come to town only days earlier with a message of warning against Catholics and their plot against the Republic.

If the name Lyman Beecher sounds familiar, it should. His daughter was Harriet Beecher Stowe, the abolitionist and author of *Uncle Tom's Cabin*, which became a bestseller when it was released in 1852. In fact, it knocked another novel written by a woman off the top of the charts. That book? *Awful Disclosures* by Maria Monk.

What happened next is an example of one of the ugliest events in Boston's history. The distrust and suspicion in the community boiled over. Behind the scenes, a group of men decided to take matters into their own hands to rid Boston of its only convent in the most vulgar way imaginable—they would burn it down.

On the evening of August 11, 1834, a mob charged up the hill of Mount Benedict to the doors of the convent. They demanded that Elizabeth Harrison be released to them, for her own safety. The mother superior asked the crowd to leave, and when they didn't, she threatened them by telling them she'd call upon thousands of Irish men at her disposal. This did not go over well.

The mob dispersed but returned a few hours later with torches. Their numbers grew from fifty to hundreds as they beat down the door to the convent and began to set the grounds on fire. The nuns and their young female students escaped out of the back of the convent, running into the neighboring garden. They witnessed their home being burned to the ground.

Several fire companies turned up at the site only to serve as spectators, if not full participants, in fanning the flames. Bonfires were made on the grounds, and anything worth carrying out of the convent buildings was tossed into the flames—Bibles, furniture, china, documents—all turned to ashes, if not pocketed as prizes. Men swirled around the grounds in priests' vestments, sang songs and otherwise caroused. Within an hour, the convent was a heap of stones, in ruins.

The next day, there was an outcry by the public and public officials condemning the mob and their deed, but the outcry rang hollow. Within the next few weeks, a handful of men were rounded up to pay for the crimes of arson and burglary, but ultimately, only one young man, a sixteen-year-old, was found guilty. (His sentence was later commuted, in large part thanks to the support of the Ursuline nuns.) The mob of hundreds of men, some of whom were charged with protecting the public as firemen, had all gotten away with the unthinkable—the complete destruction of a convent.

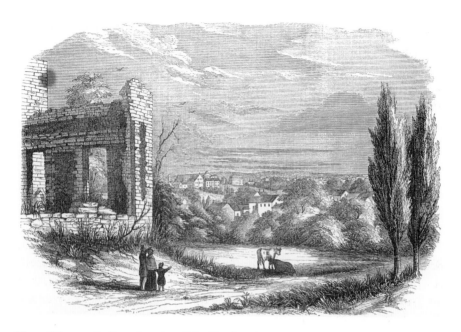

View of Somerville from the ruins of the Ursuline Convent. Wood engraving, 1854. *Courtesy of the Granger Historical Picture Archive.*

For years, the Catholic diocese asked the state legislature to release funds to rebuild the convent, but the measures were routinely defeated by the Protestant lawmakers. The ruins were left in place for years; some of the stones are said to have been used in the vestibule of the Cathedral of the Holy Cross in the South End—a fitting, if not humbling, use, since the cathedral is the largest Catholic church in all of New England.

Chapter 5

FUGITIVES TO FREEDOM

Ellen and William Craft, 1849

The hall hummed with an electric anticipation. Friends and colleagues spoke excitedly about the night's program. With barely a seat left, attendees scanned the room for any place to sit. Gentlemen offered up their seats to the ladies, and the men headed to the rear to stand. The room started to warm, a welcome development on this cold January evening. Boston's abolitionist elite and their supporters were prepared for a meeting like no other. When Wendell Phillips, the president of the Massachusetts Anti-Slavery Society, strode across the stage of Faneuil Hall, the convivial crowd quickly turned their attention to the speaker; Phillips spoke so passionately on the subject of slavery that he was known across the United States as "abolition's golden trumpet." He welcomed the audience to the annual meeting of 1849 and began to introduce the evening's featured guests. His voice rose with emotion as he described the extraordinary couple: "Future historians and poets would tell this story as one of the most thrilling tales in the nation's annals and millions would read it with admiration!"

He then turned to Ellen and William Craft. They scarcely knew what to do with themselves. Only a month ago, they'd been slaves in the deepest South. Now, they were the celebrated guests of Boston's elite in the famous Cradle of Liberty, a coincidence not wasted on them. Not too far in the future, though, in a less favorable turn of fortune, they'd be hunted by Georgian slavers.

Ellen and William Craft were born into slavery in the Macon, Georgia area. Ellen's biological father was also her owner, Major James P. Smith;

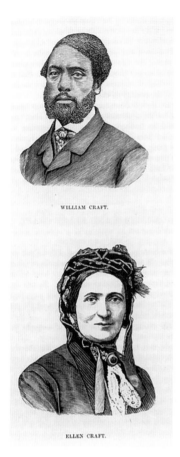

WILLIAM CRAFT.

ELLEN CRAFT.

Portraits of William and Ellen Craft. *Schomburg Center for Research in Black Culture, Manuscripts, Archives and Rare Books Division, The New York Public Library. "William and Ellen Craft."* The New York Public Library Digital Collections, *1872.*

her mother, Maria, was his slave, and she was also half white. Ellen was very fair-skinned and looked a lot like her father, which, sadly, made her the focus of the ire of Smith's betrayed wife, Eliza Smith. Eliza was so angered at guests thinking that Ellen was her own daughter that she sent Ellen as a wedding gift to Ellen's older half sister. Separated from her mother at the age of eleven, Ellen was at least lucky enough to become a ladies' maid, which meant she avoided the back-breaking work in the fields of their cotton plantation. She served her sister well through the years and earned enough respect and latitude to enable her to move into a small cabin on the property when she met and later married William.

Not much is known about William's early years. He would later tell a story of being bought and sold several times and watching as his entire family was separated on the auction block—an experience so painful he would never forget it. He was bought by Dr. Robert Collins, Ellen's new owner.

The two slaves knew each other for some time but made the joint decision not to get married. They understood that if they had children, the children were very likely to be sold off, and neither wanted to bring a baby into a world of slavery or make themselves so vulnerable to the heartache of breaking up their family. They fantasized about escaping to freedom, but the odds they were up against were formidable, to say the very least. They'd heard tales of escaped slaves before, but those slaves were usually from the states, like Virginia and Kentucky, that bordered free states. An escape from the Deep South meant defying nearly insurmountable odds, and one involving a couple traveling together was unheard of. When considering their options for freedom, they knew they had to have a solid plan in place. To be hunted, caught and taken back into slavery would put them in a terrifying position.

They would be stripped of the relative comforts in their positions as ladies' maid and cabinetmaker. They would most certainly be separated and be punished in ways unimaginable even to them. They examined their options for years before they eventually asked for their owners' consent to get married and never stopped dreaming of freedom.

When they finally did devise a plan, they acted fast. Within eight days, they were on the move.

Christmastime presented a unique opportunity. This was the one time of the year that slaves who were in their owners' good graces might be granted a small amount of leniency and flexibility. Because both Ellen and William were considered "favorite" slaves, they both asked for travel passes for the Christmas holidays, and they were granted—though William's manager urged him to return as soon as possible. With this first piece of the puzzle in place, they rapidly got to work in securing a list of other items needed to pull off their elaborate and risky plan. Because Ellen could pass as white, they decided that she would disguise herself as a man, and William would act as her slave. It was key that she dress as a man because even a white woman could not travel alone with her male slave under any circumstances. Thus disguised, they would make their way to Philadelphia and freedom.

Gathering the items for her disguise was in itself high-risk; slaves generally were not able to buy clothing, hats and glasses on the open market. But where there's a buyer, you could usually find a willing seller, even if it was in secret. Over time, William spread out his purchases of a top hat, cane and overcoat for Ellen; buying them all together would cause suspicion. As the Crafts explain in their autobiography, *Running a Thousand Miles for Freedom*, being black was the only justification needed to be questioned, searched, arrested or worse. They needed to be hypervigilant.

Once their disguise was in place, they had a bigger job in figuring out how to hide their illiteracy. They couldn't read train tickets, and Ellen wouldn't be able to sign her name on a hotel registry. Ellen decided to wrap her arm in a poultice to render herself lame. They did the same to hide her smooth face; they wrapped another poultice around her chin and tied it to the top of her head. The last piece was a pair of green tinted glasses, which they both hoped would hide Ellen's eyes, which might betray her emotions. They were both petrified as they set out on their journey, and they could not afford a look, a glance or a tear to give them away.

They left just before dawn on December 21, 1848, and arrived in Philadelphia on Christmas morning. Along the way, they evaded capture at least once and had several heart-stopping close calls; even with their white

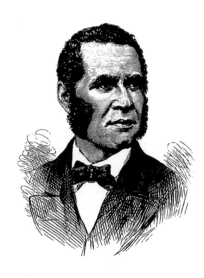

William Wells Brown, friend and mentor to both William and Ellen Craft. *Schomburg Center for Research in Black Culture, Manuscripts, Archives and Rare Books Division, The New York Public Library. "My southern home: or, The South and its people."* The New York Public Library Digital Collections, *1880.*

owners present, the rules in the South made it almost impossible for blacks, free or not, to leave. Southerners were on high alert for potential escapees, and checkpoints were set up in the major port cities—checkpoints that William and Ellen were not aware of until they faced them. Call it luck, call it divine intervention. But a combination of good timing, the kindness of strangers and the sympathy elicited by Ellen's disguise as a lame traveler got them through. Their journey consisted of a series of train and steamer travel from Macon to Savannah, to Charleston, to Baltimore by way of Richmond and finally to Philadelphia— all in five days. For their entire journey, they had to remain separate because white masters and black slaves wouldn't have shared quarters, but they checked in on each other frequently, causing some white travelers to notice how kindly William's "master" treated him, and they strongly advised the "master" against such kindness.

Once in Philadelphia, they could not let their guard down. William got a tip from another slave he met on their trip on a place to stay that was run by abolitionists. Once there, they were greeted with open arms. The owners spread the word of Ellen and William's great escape among the local abolitionist community, and soon, they were hosted by the well-known leaders of the Underground Railroad and the Philadelphia Vigilance Committee. While there was a lot of excitement around the news of their remarkable escape, it was important for them to move on from Philadelphia quickly, since it was so close to that great divide between North and South, the Mason-Dixon line, and the slave hunters who were soon to follow. They laid low with a Quaker family outside Philadelphia and were visited by William Wells Brown, a former escaped slave who'd gone on to become an educated man of means; he was a historian, author, playwright and lecturer. He was particularly active with the Massachusetts Anti-Slavery Society and asked William and Ellen to accompany him on his next series of speaking

engagements throughout Massachusetts. He wrote an article about the Crafts for the *Liberator*, William Lloyd Garrison's influential abolitionist newspaper, heralding the upcoming arrival of the couple in Boston. Their official coming-out party coincided with the annual meeting of the Massachusetts Anti-Slavery Society, where they were warmly welcomed by the abolitionist crowd. But before they settled in town, they joined William Wells Brown on a speaking tour of Massachusetts. They visited sixty towns across the commonwealth, filling seats wherever they went.

When they finally settled down, they stayed with Lewis and Harriet Hayden, another former-slave couple who were operating a "station" on the Underground Railroad at 66 Phillips Street on the "back side" of Beacon Hill, then the largest African American neighborhood in Boston. They started to build their life together; Ellen was in demand as a seamstress and as an upholsterer for William's new business selling restored furniture. Unfortunately, their ability to rest easy was completely upended before the end of 1850.

The Fugitive Slave Law was signed on September 18, 1850. The federal law granted local governments the authority to capture any black person under the suspicion of being an escaped slave and return them to their owner. There was no trial, no jury. It was only a slave owner's word against a black person's; therefore, there was little chance that the owner wouldn't prevail. Anyone interfering or caught aiding an escaped slave also faced significant fines and jail time. The law was a compromise giving greater power to slave owners over their "chattel" in return for California entering the Union as a free state and the end of the slave trade in the District of Columbia. This was terrifying news for William and Ellen. Hundreds of blacks in the free states left for Canada immediately. William and Ellen decided to stand their ground, and the people of Boston stood behind them.

There were rallies addressed by Wendell Phillips and Frederick Douglass. New organizations were formed to keep "the colored inhabitants of Boston" safe. Black Bostonians formed a League of Freedom to join together to resist the law. Boston's finest Brahmins were on deck to thwart attempts to harm any fugitive slaves or free people of color in Boston. They all put their money where their mouths were when John Knight arrived in Boston in October 1850 all the way from Macon, Georgia.

Knight asked to meet Ellen. He said that he came with news about her mother. This might have been true, but it didn't take long to find out that he had a traveling companion, Willis Hughes, the Macon town jailer. The two were in Boston to capture William and Ellen and take them back.

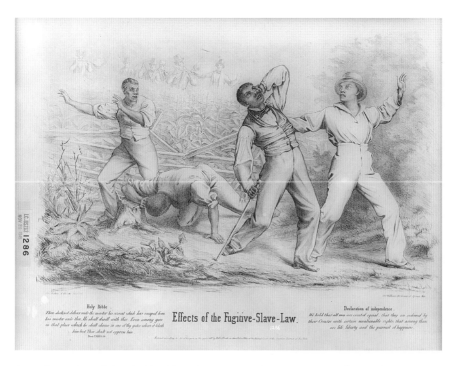

A condemnation of the Fugitive Slave Act. The photo shows a group of four black men—possibly freedmen—ambushed by a posse of six armed whites in a cornfield. *Courtesy of the Library of Congress Prints and Photographs Division, Washington, D.C.*

Boston's abolitionist community stepped into action quickly. They blocked every attempt that Knight and Hughes made to get a warrant for arrest. They even downright harassed them, citing them for smoking in public, swearing and driving recklessly, among other petty grievances.

Once the bounty hunters were able to obtain a warrant, the abolitionists split the couple and kept them in various safe houses in and around Boston to help them avoid arrest. William stayed mainly with the Haydens, while Ellen was shuttled between houses in Beacon Hill and Brookline. While staying with the Reverend Theodore Parker at Exeter Place on Beacon Hill, tensions ran so high that while the reverend prepared a Sunday sermon, he sat armed with a cutlass and pistol at his side. The Vigilance Committees were true to their word.

Finding their efforts successfully stymied over and over again, the slave hunters left town by November, but there was no room for celebration. Dr. Collins would not take "no" for an answer; he wanted his escaped slaves returned immediately and wasn't beyond going straight to the president

of the United States himself for assistance. In response, President Millard Fillmore suggested that if ordinary measures would not work to bring the former slaves "home," he would be obliged to send in the military to make it so. The Crafts decided to move on to England while they still had a chance.

On November 7, 1850, Reverend Parker officiated at the lawful and church-approved wedding of Ellen and William Craft before they sailed on to England. Because they were granted no dignity as slaves in the South, their owners only allowed them an unsanctified wedding on the plantation, a ceremony called "jumping the broom." With this final piece of their new lives in place, the two traveled the Underground Railroad to England by way of Halifax, Nova Scotia, and arrived in London in December 1850.

They lived in the London area for the next nineteen years, attending the Ockham School under the auspices of some very prominent and wealthy supporters there. They learned to read and write and eventually published their own account of their escape from slavery, called *Running a Thousand Miles for Freedom.* They settled down and had a family of five children in the Hammersmith neighborhood of London and, along the way, lectured to make money and started their own business as boardinghouse owners. Ellen even managed to raise enough funds to bring her mother, Maria, to England from Georgia after the fall of the Confederacy in 1865. But the pull of home was hard to resist. In 1870, they returned to Boston briefly before moving back to Georgia to start a school. The Woodville Cooperative Farm School was opened outside Savannah in 1871 to educate former slaves.

From fugitive slaves to public speakers addressing standing-room-only crowds, from those who could barely identify the letters in the alphabet to the authors of a bestseller, William and Ellen Craft didn't just achieve freedom but became the very embodiment of the best of the Brahmin Boston tradition—upstanding leaders in their respective communities, willing to stand up for what they believed in and to share the gift of education.

Chapter 6

PHOTOGENIC PHANTASMS

William Mumler, Spirit Photographer, 1861

The door cracked open, revealing a busy photography studio on 170 West Springfield Street in Boston's South End. A gentleman whose portrait had just been taken stood and stretched after sitting still for so long. A veiled woman was brought into the sitting room by the photographer's assistant. She surveyed the room, sizing up both the gentleman and the photographer. Her veil was so impenetrable, it was difficult to hear her speak, but she approached the gentleman and asked if he'd had his photo taken. Indeed, he said, he had. She asked him, "Do you recognize it?" He answered that although he wasn't skilled at looking at photographic negatives, he believed that he could. Satisfied, the woman asked the photographer what he charged and immediately requested a sitting. Pleased, the photographer went into his dark room and prepared a plate. When he returned, she was already seated. Removing her veil, the picture was taken. In three days' time, her photograph would be ready, whereupon one of the most famous or notorious photographs ever produced would be made public.

Three days later, Mrs. Lindall, as she asked to be called, returned to the studio at the appointed time and likely got more than she bargained for. An envelope containing her photos was given to her by the photographer's wife, who also, conveniently as it turned out, happened to be a medium. Mrs. Lindall opened her package and was pleased to find that the photos turned out successfully. She started to put the photos away but was interrupted when the photographer's wife abruptly fell into

a trance. Channeling a familiar voice from the Beyond, she turned to Mrs. Lindall and said, "Mother, if you cannot recognize Father, show the picture to Robert. He will recognize it." Confused, Mrs. Lindall said that she did recognize the figure hovering over her in the photograph, but to whom was she now speaking? "Thaddeus!" came the answer. Mrs. Lindall was overcome with joy. What were the chances that her long-deceased son would contact her through a medium right here in the photography studio? It only added to her elation at seeing the photos in her hand. The photographs were tangible proof that her husband still cared for her, even from the Other Side.

So badly had she wanted this proof that she had come all the way from Springfield, Illinois, traveling incognito, to sit for the famous spirit photographer William Mumler in his Boston studio. She was comforted knowing that just three days ago, here in this studio, the spirit of her husband had appeared standing behind her, his head bowed and hands firmly placed on her shoulders in a protective but loving stance. Mary Todd Lincoln would never forget this moment.

William Mumler rose to fame in 1861 as the first of several famous spirit photographers in the United States and Europe, after he stumbled upon a way to apparently photograph people accompanied by their deceased relatives or friends. At that time, Mumler was working as an engraver for a Boston jeweler and practicing photography as a hobby. On Sunday, October 5, 1861, he was using the studio of a Mrs. Stuart at 258 Washington Street in Downtown Crossing to produce a self-portrait. After the photograph was developed, he noticed a figure of a young woman sitting in a chair behind him. The image had a ghostly, transparent quality, and Mumler immediately recognized the specter as his departed cousin.

He experimented again and again, producing the same effect. Before long, after telling a few people about his experience, he tested his process with twenty people, and most recognized their disembodied dearly departed sitting beside them, hovering over them or otherwise mysteriously appearing in their portraits. None of the photos were alike, and all of the sitters were convinced that the photos were genuine. By the end of 1862, Mumler was celebrated in the pages of the most popular Spiritualist newspapers in the United States.

Perhaps aided by a sixth sense for marketing or getting a psychic tip-off from his wife, Mumler began his practice of spirit photography at exactly the right time in history. There was a convergence of the fascination of spiritual phenomena, an interest in the relatively new technology of photography

A spirit photograph of a girl surrounded by spectral figures of women holding infants. Photograph by G.S. Smallwood, circa 1905. *Courtesy of the Granger Historical Picture Archive.*

and a time of great upheaval and loss during and after the Civil War. An idea has its time, and Mumler was able to profitably capitalize on it.

Spiritualism, a newly formed religion, sought to definitively prove that the dead lived on in another realm and could be in communication with the living with the help of a Spiritualist medium. Its adherents were interested in using new technology and science as a means to better understand the spirit world and traditional religion. Spiritualism offered an alternative to more conservative and restrictive Protestantism that was, for many, too caught up in rule-following and tradition. Traditional religions too often neglected to connect the awe and wonder of the natural world to the spiritual experience and instead focused on traditional roles, rules and structures. Spiritualism tried to make the magical more accessible to its followers and opened the door to those, like women, who had no opportunity to truly participate within the confines of traditional Christianity. While Spiritualists focused on the connection between the living and the dead, they attempted to use science to prove that connection.

Sheet music cover page of a song called "Spirit Rappings" from 1853. *Courtesy of the Creative Commons.*

Spiritualism got its start in upstate New York in 1848, when two preteen girls, Kate and Margaret Fox, claimed to communicate with the dead. The girls could call upon spirits who would answer in a series of claps and knocks on walls or furniture. When word spread about their gift, a group of the spiritually curious started to hold weekly séances to learn from the spirits the girls were able to summon. So-called experts were consulted to confirm the girls' legitimacy. No one could dispute their unique talent. After their first public showing, interest in the mediums started to spread like wildfire across the country. Only three years later, Spiritualist groups could be found in New York, New England and as far west as Pittsburgh, Pennsylvania.

While many were attracted to the religion of Spiritualism because of the appeal of an afterlife and the consolation offered in the knowledge that deceased family members and friends were well and happy in the Beyond, others found an easy way to use the religion to prey upon the innocent and vulnerable. Countless mediums were exposed as frauds. Because of the low barrier to entry for such fraudulence and an interest in bringing some scientific rigor to proving that spirits existed, organizations were founded to both prove the existence of spirit "life" and to debunk so-called spirit communicators.

Spiritualism spread across the country with the help of not only mediums' lectures and public séances but also newspapers that were founded to spread the word of the latest otherworldly findings. The *Banner of Light* was one such newspaper that was based in Boston. Available in both the United States and Europe, the *Banner of Light* was the longest lasting and most influential of the metaphysical magazines. In 1862, the weekly helped to disseminate the news about Mumler's great discovery.

With the *Banner of Light*'s endorsement, Mumler became the talk of Boston, hosting hundreds of sitters, some of whom were locally or nationally famous. They first came from all over Massachusetts and then from all over the world. Doctors, lawyers and merchants. Men and women. Young and old. All had an interest in buying photos of themselves with a blast from the past hovering close by. One sitter even tried to mentally imprint his desire to be joined by the spirit of the great orator Daniel Webster, and his wish was granted! Some cried; others shouted out in joy. Some came with inquisitive minds, and Mumler was always open to allowing his camera to be taken apart and inspected, his negative plates cleaned and his dark room to be given the once-over. All appeared to be above board. But was it?

Aiding Mumler in his business was his wife, a medium in her own right who used her powers for energy healing, as well as spirit communication at portrait sittings. Mrs. Mumler would prime the spiritual pump by putting

her hands on her husband's clients, enervating a channel of spiritual energy that could be so strong that the clients often fainted. When asked what spirit conducted this ability in her, the spirit pronounced himself to be none other than Benjamin Rush, the Revolutionary War–era doctor. This couple had significant credibility!

Despite all that, Mumler was gaining a reputation as a swindler in Boston. Feeling betrayed locally, as well as pulled by the untapped market elsewhere, he and his wife moved to New York City in 1868 to establish a new photography studio at 630 Broadway. After a short time, Mumler was again so successful he could buy out his initial business partners' interest and go out fully on his own.

Mumler's successful run was impeded by a trial for fraud. One of the foremost legal minds of the day, Elbridge T. Gerry, the grandson of former Massachusetts governor and vice president of the United States Elbridge Gerry, mounted a formidable case against Mumler. He used testimony of those who felt duped by Mumler when they didn't recognize the so-called spirits showing up in their portraits.

Mumler's defense team brought in an expert witness to testify that all of his equipment and processes had been inspected over and over again and nothing had ever been found that would suggest that Mumler was deceiving his customers. Other photographers were called to take the stand and testified that they knew of no other legitimate way to produce the effects that Mumler was achieving; it could only be what he said it was—capturing the image of spirits. Other photographers suspected that Mumler was a fraud but could not say for certain how exactly he was incorporating the incorporeal. Even P.T. Barnum, showman extraordinaire and no stranger to the more-than-occasional exaggerated claim, was brought to the stand. He claimed that Mumler had consulted with him and the two wrote letters back and forth. Mumler had even given Barnum copies of his portraits with the apparition of Napoleon sighted in the background for display in Barnum's book called *Humbugs of the World*, a book that exposed all manner of fraud and chicanery. If Mumler had indeed allowed his work to be displayed in such a book, didn't he then knowingly admit to making false representations? Mumler said that he'd never engaged in such a transaction with Barnum. Unfortunately, the letters between the two had been lost in a fire, meaning that Barnum could offer no proof.

On and on the arguments went, but in the end, Mumler prevailed. There was no proof beyond the shadow of a doubt that he knowingly defrauded his customers. The trial's outcome was not only the direct

result of so few people understanding the technology behind photography but also an interesting societal openness to the domain of the spiritual. Mumler's attorney successfully argued that just because one client couldn't recognize the specter that turned up in their portrait didn't mean that it wasn't a legitimate spirit. It could have been the result of a missed spirit connection—somehow the spirit wires got crossed along their magical transmission. That could neither be proven nor denied. Mumler was free. The headline of the *New York World*'s May 4, 1869 announcement of his victory read, "The Triumph of the Ghosts."

Soon after, Mumler returned to Boston, where he commenced with his gambit to prove his legitimacy by offering himself up to investigation. He worked for several months using the same camera, equipment and dark room as another non-spirit photographer and continued to produce spooks. He allowed others to test his procedures by preparing all of the equipment for him and still had no trouble conjuring spirits. Despite the cloud of suspicion that hung over him, he continued working in the realm of spirit photography until he himself left this world on May 16, 1884.

Today, spirits are usually photographed only on ghost tours of purported haunted neighborhoods where fuzzy orbs can stand in as spirits or on cable-television shows that claim to capture trespassing shades on video with use of highly technical equipment. Mumler was never proven an outright fraud in his lifetime, but he was indeed a fraud.

University of Cambridge faculty member and novelist John Harvey explains in his book *Photography and Spirit* that Mumler used what is called the "wet-collodion process" that involved developing two glass plates at once with a careful balance of light-sensitive chemicals. Mumler definitely had a gift for pulling off a rather complicated process but not a gift for bringing the dead to light. It's not really clear how Mumler got an original photograph of the sitter's chosen deceased relative to incorporate into a spirit photograph. It is speculated that his assistant was tasked with either stealing photographs of deceased relatives from his sitters' homes and bringing them to Mumler to be transferred for use as spirit photos or stealing the photographs first and then convincing the victim to see Mumler for a photo portrait. In either case, Mumler, his wife and assistant willfully conned their customers, but it would seem very few complained or filed suit against him.

Perhaps the Harvard philosopher William James got it right in his 1896 lecture "The Will to Believe" when he said, "Belief creates the actual fact." And perhaps P.T. Barnum also got it right when he was reported to have said, "There's a sucker born every minute."

Chapter 7

THE BOY TORTURER

Jesse Pomeroy, 1872

Mothers in Chelsea were petrified that winter of 1871. The newspapers were reporting that someone was hunting their children by enticing them out from under the watchful view of their neighbors and taking them to remote places their parents had warned the children about. There, the perpetrator would beat the victim within an inch of his life and leave him for dead, naked and roughly tied to a post. Further details of the beatings were far more disturbing than reported, but the newspapers chose to add their own fanciful descriptive characteristics, including the fiend having a pointed red beard and long, sharp fingernails. The newspapers dubbed the criminal the "Red Devil."

Even though the headlines were terrifying and mostly true, the newspapers had missed the mark. By concentrating on the exaggerated and fictionalized characteristics of a very real threat, they allowed the menace to strike again. The truth, in fact, was far more chilling than the fiction written in the papers. When the public realized that the demon living among them walked their streets, visited the same stores and vendors and attended the same school as their children, their perception of easy and innocent childhood was completely upended.

The supposed Red Devil was a twelve-year-old boy named Jesse Pomeroy. He continued to haunt the streets of Chelsea and South Boston until his troubling and abusive acts finally reached their natural conclusion: murder.

Jesse Pomeroy was born on November 29, 1859, the younger of two boys, and grew up in Charlestown. Jesse was a spirited young boy who

didn't let a cloudy white mark over his left eye hold him back. While his older and well-behaved brother, Charles, was helpful around the house, Jesse was another story. His less-than-perfect behavior all too often found him the focus of brutal beatings by his abusive father. Thomas Pomeroy was an angry drunk who could rarely hold down a job. The raging pain in his head, physiological or not, made it impossible for him to work; the only tonic for the pain was more alcohol. The misbehavior of his son, as well as the boy's embarrassing deformity, was enough reason for him to lash out with almost deadly beatings. On one occasion, he made Jesse strip before lashing him with a horse whip. After finding Jesse naked in a corner of the home, shivering and withdrawn, his mother, Ruth Ann, took the (at the time) drastic step of divorcing her husband. She had a soft spot for poor Jesse and would always be his greatest defender.

Even without the ominous presence of Thomas Pomeroy around the house, Jesse continued to act out, particularly at school, until he was asked not to return. The children at school teased him relentlessly about his too-large head and odd, milky white eye. Instead of running home and hiding his head in his mother's skirts, Jesse fought back—perhaps a little too vigorously. When he wasn't fighting back, he ignored the taunts, as he became increasingly less engaged in making friends and interacting with children at school. He started to develop a numbness to the abuse heaped upon him both at home by his father and by childhood bullies and mean classmates. In addition, he paid the teachers and their lessons no mind at all. When he read, he preferred cheap dime-store novels to entertain him with their tales of violence and adventure.

Living in Charlestown, out of school for the time being and not particularly driven to contribute at home, Jesse found other ways to entertain himself. Unfortunately, what brought Jesse satisfaction was inflicting pain on other living beings. Early on, his mother recounted coming home and expecting to hear the lovely singing of her two pet canaries. One day, she entered the home to silence. Wondering why, she rushed to the cage, where she found both birds lifeless—and headless. A neighbor also told the tale of how her new kitten went missing until it was found dead in the bloody hands of Jesse Pomeroy. That Jesse could do such monstrous things was chilling, but that he felt no remorse, no guilt, no nothing, could make a heart skip a beat. And Jesse was just getting started. Birds and kittens were too easy. His next target moved up the food chain to other children—children smaller than himself. It was the perfect set-up; he was twelve years old and big for his age. Little

boys looked up to big kids like Jesse. They naturally wanted to please him, to curry favor. If Jesse could entice them with a promise of a sweet or a circus show, they were sure to follow him. And they did, to their detriment, to put it mildly.

Jesse's first known victim was Billy Paine on December 26, 1871, and then ten-year-old Tracy Hayden on February 21, 1872. The first victim to make headlines, though, was eight-year-old Robert Maier, who was found naked, bleeding and almost frozen to death. Jesse's mode of operation was the same with all three abductions, although the violence and pain inflicted worsened every time. Robert had been playing by himself in nearby Chelsea. Jesse walked by, and the two started to throw rocks together. Jesse told Robert about the circus coming to town and asked Robert if he'd like to check it out. Of course Robert would! The two started off but somehow along the way veered off course, toward Powder Horn Hill. It may have registered for Robert that they weren't going to the circus as promised, which was a surprise, but he never expected what happened next. Jesse suddenly overpowered Robert and threw him into a pond, almost drowning him in the shallow and frigid water. Robert was barely allowed to catch his breath before Jesse bashed his head with a large rock, dragging his semi-conscious body to a nearby shack. There, Jesse stripped Robert naked and tied him to a wooden beam. He hit Robert over and over again with a stick, lashing and drawing blood. All the while, Jesse pranced around him, laughing and yelling expletives. Jesse made Robert repeat his foul words, getting more and more excited as Robert screamed out in pain. Eventually, in a culmination of ecstasy, Jesse pleasured himself and then moved on, leaving little Robert for dead. A passerby stopped when he heard a whimpering coming from the shack and called the authorities.

All of the boys described their attacker as a big boy with a large head and a white cloud over his eye.

From then on, the news was full of reports of the Red Devil's cruelties. Parents in Chelsea feared the worst. One of those parents was Ruth Ann Pomeroy, who decided that enough was enough. She moved herself, Charles and Jesse to South Boston to make a fresh start. Jesse was accepted into the Bigelow School at the corner of E and Fourth Streets. For all too short a time, life was good.

Then, the Boy Torturer, the new moniker for the young criminal, struck again. Not coincidentally, this time it was in Southie. Only days after the Pomeroys' move, newspapers reported that seven-year-old George Pratt was abducted from the Savin Hill neighborhood, tied to a post and not just beaten

with a stick but stuck with a long sewing needle all over his body and genitals. Additionally, George endured a large chunk of flesh bitten from his buttocks. He described how the Boy Torturer had poured fresh sea water into the wound to inflict deeper, more intense pain. George described a big boy with a big head and a white cloud over his eye. The Boy Torturer was in Southie now.

Jesse's last victim, for the time being, was five-year-old Joseph Kennedy. Joseph was lured out by way of the train tracks in South Boston and found tied to a telegraph pole. He suffered the same injuries and abuse as the other victims and described the same child monster. Joseph must have been a very brave five-year-old because he agreed to go to all the schools in South Boston with Officer Bragdon to see if they could find the Boy Torturer together.

One school on their list was the Bigelow School. When they entered Jesse's classroom, Jesse ducked behind the book he was reading and miraculously went unnoticed. More miraculously and inexplicably, Jesse decided to stop by Police Station #6 at 194 West Broadway Street on his way home from school. The first two people he saw when he entered were Officer Bragdon and little Joseph. The jig was up.

Jesse admitted to his crimes and, in a fairly cut and dried case, was sentenced to the State Reform School in Westborough until he was eighteen years old. There, he behaved well enough and made himself useful doing small jobs. It seemed like he might have been reformed, cured of his twisted violent streak. Jesse's mother was able to pull some strings and petitioned for Jesse's release. Because of Jesse's good behavior, he was allowed to return to South Boston under the care of his brother and mother, who needed the help with a dress shop she'd just opened on Broadway Street, over her son Charles's newsstand. Jesse's reintroduction into the neighborhood was a very quiet one, which authorities later regretted.

Had Mrs. Curran known that Jesse Pomeroy was back in town and living just down the street from her, would she have allowed Katie to walk down the street in search of school supplies? And would authorities have been quicker to respond to her claim that her ten-year-old daughter had been snatched up off the street? Katie was not the type to just run off on her own and never return home. The last place she'd been seen was Charles Pomeroy's shop on March 18, 1874, just six weeks after Jesse returned home. Jesse was questioned. He denied knowing anything of Katie's whereabouts; he hadn't left the store all day. The shop was searched, but nothing out of the ordinary turned up. Surely, something sinister was behind her disappearance, but after searching for just a few days with no trace of Katie Curran, she became no more than the coldest of cases.

Police would return to the disappearance of Katie Curran about a month later, after two young boys out to dig for clams in the mudflats near Savin Hill made a gruesome discovery. There, half submerged in the mud, his legs at odd angles that belied the wild flailing in the struggle for his life, laid what looked like a porcelain doll. It was the body of Horace Millen, a four-year-old so sweet and beautiful that his mother occasionally dressed him in dresses. His murder had been vicious. His pants were hastily pulled down around his feet, his neck so deeply cut he'd almost been decapitated. He had been stabbed eighteen times on his torso and chest and at least once in his right eye. His genitals had been cut off. It was sickening. It was also familiar.

Police immediately knew where to turn—back to 312 Broadway, the home of Jesse Pomeroy. When confronted with the murder, Jesse dispassionately admitted to everything. He was thrown into the Charles Street Jail to await trial, but in the meantime, something didn't quite smell right. And that smell was coming from the basement of Ruth Ann Pomeroy's dress shop.

After Jesse was caught and confessed to the murder of Horace Millen, business at the Pomeroy's dress and newspaper shops very quickly fell off. Ruth Ann moved her business to her home, and as the building came under new ownership, work commenced on some excavating and cleaning in the basement. By then, July 1874, the neighbors were complaining of a horrible odor coming from the building. On July 18, workers found the origin of the odor: the decomposing body of Katie Curran.

Jesse was tried for the deaths of Horace and Katie in December 1874, less than a year from the date he was released from reform school. In a matter of days, he was found guilty. Because of his young age, he wouldn't face the hangman's noose. He was sentenced to life imprisonment in solitary confinement and served his sentence at the Suffolk County Jail in Charlestown, his old neighborhood. He spent the next fifty-odd years trying to break out of jail (almost successfully), learning several new languages and representing himself on several legal appeals for a pardon based in part on the illegality of such a long sentence of solitary confinement. In 1929, he was transferred to the Bridgewater Hospital for the Criminally Insane, where he died in 1932.

Chapter 8

SMALLPOX SMACKDOWN

Dr. Durgin versus Dr. Pfeiffer, 1901

Boston was in the grip of one of the greatest smallpox epidemics in years. In a three-year span, 270 people died and 1,596 cases were reported. The city of Boston was doing all that it could to stop the disease from spreading. People were treated in a smallpox hospital on Southampton Street in the South End, and when it ran out of beds, the Gallop's Island quarantine facilities were expanded to meet the need.

A huge controversy regarding vaccinating the populace raged in the papers and among the medical intelligentsia of Boston. There were those who believed strongly in the power of vaccination to protect the public from an epidemic such as the one in Boston at the time. The antivaccinationists, even the scientists among them, believed in the right to do as one pleased with their own body or in God's power to supersede the choice. In the latter case, government was not a welcome interloper.

This was not the same disagreement caused by Cotton Mather's quest in 1721 to rid colonial Boston of the disease by working with Zabdiel Boylston to experiment with inoculation. But when this contentious issue erupted again 180 years later in 1901, the battle lines, in some ways, were very similar. And this time, it would culminate in not only a landmark Supreme Court case but also in a man deliberately contracting the disease to prove a point. It just wasn't exactly the point he wanted to prove.

Smallpox was a terrible virus that could rip through a family, a village or a city with terrifying speed and deadly results. The virus was intensely virulent; its mode of operation was to infect one person, who spread it to

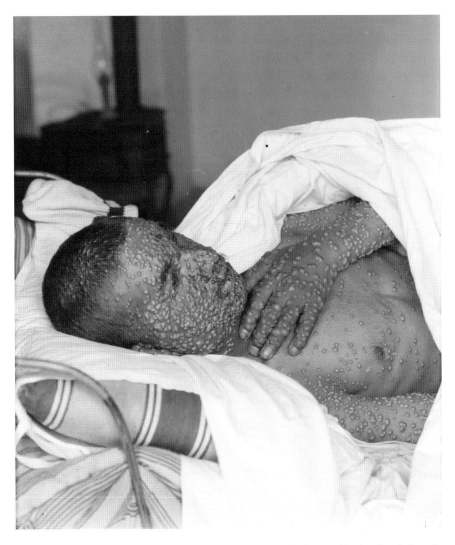

This photo shows the painful smallpox pustules that cover the face and body of an infected patient. *Courtesy of the Library of Congress Prints and Photographs Division, Washington, D.C.*

the next person, then the next person, then the next. A person could feel well for seven or more days after being infected and therefore continue to spread it unknowingly, but when the disease presented itself, the victim knew he had it because it was painful and unrelenting. At the outset, the symptoms were a lot like the flu—chills, fever, headache and overall body aches. After these passed in a few days' time, the pox packed a punch. Small

red spots formed inside the victim's mouth, nose and eyelids, eventually covering the whole body. The red spots then filled with a milky fluid, started to grow under the skin and became painful. These pustules spread for the next few weeks before turning into scabs. The victim then reached a tipping point—survival or death. The survivors were normally scarred badly for life and quite possibly even blinded by the pustules that formed in and around their eyes. Those who died were killed by toxemia or hemorrhaging; the virus invaded the internal organs and wreaked havoc in the lungs, stomach, intestines and throat. In colonial times in Europe, the disease killed an estimated 400,000 a year and can be blamed for the eradication of entire populations as Europeans started to explore North America.

The story of the Reverend Cotton Mather's and Dr. Zabdiel Boylston's early testing of inoculation in colonial Boston is well known and paved a path for the rest of the country to slowly accept inoculation as valid science. Inoculation had come a long way between 1721 and 1901. In 1796, Edward Jenner discovered that cowpox virus worked against smallpox in humans, and slowly this became the accepted way to ward off the disease, this time by vaccination and not inoculation. Even vaccination was met with fear and confusion; it was not at all logical that introducing cowpox into the human system would be a good thing. Cartoons depicted people turning into cows. But the fact is it worked. As Jenner's vaccine was used more and more, the periods between epidemics got longer and longer. But as the success of vaccinating people grew and the instances of smallpox outbreaks decreased from year to year, a certain complacency crept in, allowing for smallpox to rear its head again and again.

Finally, by 1855, Massachusetts became the first state to legislate that all children be vaccinated against smallpox before being allowed to start public school. But with every cycle of remission to outbreak, the same policy arguments were played out again and again—those on the side of science and medical proof that vaccination should be mandatory versus those on the side of personal or religious liberty that acknowledged only the risks and none of the benefits of universal vaccination. At the time, there was a small risk of actually dying from smallpox after receiving a vaccination or from other complications connected to vaccination. However, the number of deaths was miniscule.

Yet the effects of vaccination lasted, at best, only seven to ten years; people needed to be re-vaccinated. Re-vaccination was easy enough to fall off people's to-do lists, again fueling smallpox outbreaks and the controversy that came along with the call to vaccinate.

Right: Some sarcasm thrown at leaders in Washington, D.C., over requiring smallpox vaccination. *Courtesy of the Library of Congress Prints and Photographs Division, Washington, D.C.*

Below: An inspector for the board of health vaccinating tramps. *General Research Division, The New York Public Library. "Sanitary Precautions against a Smallpox Edpidemic—An Inspector of the Board of Health Vaccinating Tramps in a Station House."* The New York Public Library Digital Collections, *1879-04-19.*

Starting in 1898, another epidemic took the United States by storm. Starting in the southern states, by 1900 it spread to the Midwest and finally to the northeastern states. The strain of the virus was milder than in the past, not quite as deadly, but authorities didn't expect it to stay that way for long. When the disease reached Boston in 1901, the board of health and its chairman, Dr. Samuel H. Durgin, did everything within their power to combat the virus. They offered free vaccinations, expanded the capacity of the smallpox hospitals and worked with the Catholic diocese to spread the word.

Still, there were those who did not believe in vaccination and the government's role in regulating the fundamental liberty of deciding what to do with one's own body. Such a person was Dr. Immanuel Pfeiffer, a physician and president of the Massachusetts Medical Rights League. Dr. Pfeiffer was a homeopath who wrote about the mind's power over the body and the power of personal hygiene over disease. He was an outspoken public critic of compulsory vaccination.

Dr. Durgin was fed up with antivaccinationists, like Dr. Pfeiffer, as they thwarted his attempts to make the city safe against smallpox. Pamphlets and fliers had hit the streets warning parents against the dangers of vaccination and advertising the name of a doctor who would write a certificate of exemption for them. In answer to that, Dr. Durgin issued a challenge that would go down as one of the cheekiest, if not the most brazen; Dr. Durgin invited any antivaccinationist to contact him if they would like the opportunity to expose themselves to the disease. Imagine the Victorian-era mic drop. He doubted that anyone would put their money where their mouth was. But he didn't count on Dr. Pfeiffer reading the *Boston Globe* that day.

Challenge accepted. Dr. Pfeiffer reached out to Dr. Durgin to ask permission to visit the smallpox ward at Gallop's Island to observe the disease. Dr. Durgin agreed and waived the requirement that all visitors have proof of recent vaccination. Dr. Pfeiffer had been vaccinated at childhood but not any time since. Dr. Pfeiffer toured the facilities and complimented the staff on its cleanliness. Before he left, he leaned in to smell an infected person's breath, making a great show of taking a deep breath. He was then instructed to wash his hands, face and beard with disinfectant before going back to Boston.

Little did he know that he was followed for the next several days by agents of the board of health; in the event that he contracted the disease, they wanted to be the first to know. Dr. Pfeiffer made his way about town—going to his office, to his apartment in Charlestown, to testify at the State House.

And then he disappeared. Just at the time when an infected person would be showing signs of the first symptoms of smallpox.

Through a frantic few days of detective work, the Boston Board of Health tracked down Dr. Pfeiffer at a farm he owned in Bedford where his children and wife lived. A doctor was called in and confirmed that Dr. Pfeiffer had an advanced case of smallpox. His home was quarantined; the Bedford public schools required that all of the children attending be vaccinated immediately, since they'd interacted with Pfeiffer's kids; and his Charlestown apartment building was disinfected and all of its residents were also vaccinated.

Authorities did not think that Dr. Pfeiffer would recover, but he did eventually. The Town of Bedford came to the brink of suing the City of Boston and its board of health for allowing this battle to go so far and sticking Bedford with the bill. While most blamed Pfeiffer for being irrationally irresponsible, others took Dr. Durgin to task for egging Pfeiffer on.

While Dr. Pfeiffer convalesced, the vaccination battle raged on, this time at the home of a pastor in Cambridgeport. Dr. Edward Spencer, the chairman of the Cambridge Board of Health, approached the home of Pastor Henning Jacobson to tell him that the family would need to be vaccinated immediately, as stated by law; the board had just determined that the smallpox epidemic had become dire, forcing them to vote to make vaccination compulsory, with violators facing a five-dollar fine, a not insubstantial amount at the time. Spencer was offering on-the-spot, free vaccinations, but Jacobson refused. He was found guilty in court for refusing the vaccination and appealed his case for the next three years, until it reached the U.S. Supreme Court on the grounds that it impeded his personal liberty.

A poster from the Chicago Department of Health urging vaccination for smallpox. *From the Works Progress Administration Poster Collection of the Library of Congress.*

In 1905, the U.S. Supreme Court reached a 7–2 decision that the Massachusetts compulsory vaccination law, when necessary for public health or safety, was indeed

constitutional and essential to promote public health. After that, smallpox cases were few and far between, mainly because of the success of mandatory vaccination. The last case of smallpox in Boston was recorded in 1932 and was last recorded in the United States in 1949 in Hidalgo, Texas. In 1971, because no cases had been reported in twenty-two years, routine vaccination was discontinued.

Chapter 9

THE SUITCASE CASE

The Death of Susanna Geary, 1905

J ust outside Boston's city limits sits the town of Winthrop. The town, named for John Winthrop, the Puritan founder of Boston and eventual governor of the Massachusetts Bay Colony, is on a peninsula settled in 1630 by a group of Puritans at the same time as Boston. Used as farmland in the earliest days, the town has a quiet history and boasts ownership of the Deane Winthrop House, the home of John Winthrop's son. When Winthrop was initially settled, the colonists called it Pullen Poynt for "Pulling Point" because the tides there are not strong, making it difficult for boatmen to pull a boat to shore. This was the same challenge that befell the men, in the fall of 1905, who decided to drop a suitcase holding a cleanly cut torso of a woman at Point Shirley, a small spit of land that reaches south of Winthrop's mainland. Most likely expecting the tides to take the suitcase out to sea and successfully hide their crime, these men were clearly not the seafaring type. Their suitcase was quickly found, perhaps only an hour after they released it, stunning Boston and the rest of the nation as buzz spread about the gruesome find. The identity of the unfortunate woman and her killer would be unraveled over the next weeks and months in an impressive display of detective work spanning several cities and states and unveiled a tragic story about a promising life cut short.

On September 21, 1905, a few young men found a suitcase bobbing in the harbor. They brought it ashore at the Winthrop Yacht Club. Hoisting it onto the dock, surprise quickly turned to revulsion and shock as they stared into the open case. There, unceremoniously stuffed inside, was

the bloody torso of a woman. A long cut ran down the middle of her abdomen, and another incision was made low down on her stomach. The police were called, and by that evening, the newspapers were screaming the news. The medical examiner was able to ascertain that whoever had done this deed knew what they were doing; the perpetrator must have been a skilled surgeon. He could also say for sure that the woman had had two operations—one illegal and the other made in a desperate attempt to save her life.

The unfortunate woman was Susanna Geary, or Ethel Durrell, as all of her friends knew her. Susanna was a dancer with the Shepherd King company, a traveling troupe of entertainers. She was born in Leominster, and her family moved to Main Street in Cambridge when she was a young girl. From a working-class family that aspired for something more, Susanna's father was a molder working for the Mason & Hamlin piano factory, and her mother took odd jobs to make ends meet. They had a piano, which Susanna loved. When she became a stage actor and dancer, her family shared in her success and wore their pride openly. She sent home money every week that she performed out of town. It was on the road that she took the stage name of Ethel Durrell, an exotic moniker that gave her a bit more flair and panache. The name stuck, and all of her family and friends called her Ethel. She was always well liked and not the type to get into trouble. But by September 10, after a performance in Boston, she was missing. Her family feared the worst after the suitcase was found. But without evidence, they could only wait and hope that Susanna would return home.

But then a letter arrived that was postmarked September 19. In it, she told her family that she wasn't feeling well and included five dollars that she owed her father, making good on her debt to him. She asked also that any letters she received at home in the coming weeks while she was out of town again be kept for her. The letter was postmarked from Salem and written in a haphazard, messy scribble. The lines didn't run neatly across the page, as they would typically in a letter from Susanna, but up and down in an almost dizzying fashion. Just by looking at it, her family knew that something was wrong. Maybe she was under the influence of some heavy painkillers or in much more pain than she let on. The latter was true. By the time the letter was placed in the mail, Susanna was already dead. Her fiancé had probably mailed it for her, knowing that she was about to undergo a serious operation. But did he know she was dead? As her fiancé, he, of course, became the first person of interest in the case, and the police called in help from their brothers in the city of Pittsburgh, Pennsylvania.

Nathan Morris worked as a transportation consultant for the Shepherd King troupe and had arrived in Pittsburgh just after their stint in Salem. When police approached him about the death of Susanna Geary, he staggered, almost falling faint. He declared his love for her and told the officers about their plans to marry the next spring in Springfield. When he left her in Boston, she was feeling ill and had gotten a doctor's certificate to miss a few shows, but beyond that, he couldn't say what had happened to her. The police had a hunch that he wasn't being completely on the up and up, and after hours of cross-examination, he finally admitted that their relationship had crossed the line of propriety, that their passion was too much to deny and that they weren't as chaste as he first said. He was probably protecting her reputation as much as his own in this matter; he didn't want to sully her name in public. It took him just as long to admit that he did know that she was planning on getting an abortion. As it turned out, he'd even helped to pay for it by pawning a diamond ring that her mother had given to her as a gift only months before. This explains why the diamond ring was missing from the fingers on her disembodied hands found in yet another suitcase. Any hope that the Geary family or Nathan Morris were holding out for Susanna being found, and found alive, was dimmed when a second suitcase was found containing her arms and legs. Her mother and sisters were able to identify the rings on her fingers, making their nightmare a reality. Susanna Geary had suffered a horrible, painful death.

After the first two suitcases were found within days of each other, the trail cooled. The police resorted to old-fashioned gumshoe work and started to fan out over the city following leads and making connections. Within days, the police had hunted down the pawnshops that had sold the suitcases and had a description of the two men who bought them. They also made a fair assumption of where the botched operation had been done: at an infamous lying-in hospital at 178A Tremont Street in Boston, run by a woman named Mrs. Bishop. Their suspicions were confirmed during their interview with Nathan Morris, but still, they lacked hard evidence. They also lacked a head.

While the torso, arms and legs of Susanna Geary were found rather quickly, the last piece of the puzzle would take a bit longer and require a bit of help to find. The men who had thrown Susanna's dismembered limbs into the sea provided that final piece of information after they were apprehended in New York City. They also pointed the finger at who had done the chop job of poor Susanna Geary.

Susanna checked into the "women's" hospital at 178A Tremont Street on September 10, 1905, and had an abortion there. She was transferred to a

lying-in hospital at 68 Winthrop Street in Roxbury to recover. But she didn't. Her condition worsened. She developed sepsis, and Dr. Percy McLeod was called in to perform lifesaving surgery. A gynecologist by training, he understood Susanna's condition to be grave; he performed the surgery and came back the next day to check her condition. It had not improved. He knew that she only had hours to live. He asked about writing out a death certificate, but the staff said that her mother didn't want the news to get out about Susanna's condition. This was a lie; Susanna's mother knew nothing of the operation. There was nothing more for him to do, so he left. The next time he heard about Susanna, it was when the police called at his home to question him about the death, shocking his friends and family.

The mild-mannered Dr. McLeod had never been accused before of being an abortionist and held tight to his claims of innocence. But it was his word against those of his accusers: Louis Crawford and William Howard. Louis Crawford was the son-in-law of Mrs. Bishop, the owner of the two "women's hospitals." William Howard was a man looking for a quick way to make $100.

According to Crawford and Howard, Susanna died on September 19. Crawford, the manager of 68 Winthrop, called Howard to help him dispose of the body. They met and visited two pawnshops, buying one suitcase at each shop. They claimed that they went to 68 Winthrop and met with Dr. McLeod, who took the empty suitcases and returned with them twenty-five minutes later. When he passed them off to the men, they were much heavier. The head was put in Susanna Geary's own handbag. The three bags were then taken to Mrs. Bishop's Tremont Street location.

In the meantime, the two hatched a plan to dispose of the luggage in Boston Harbor. But before they got started, they needed to build up some liquid courage. They visited nearly all of the bars around the corner of Tremont and Boylston Streets and hit the rum bottle hard. When nighttime fell, they stumbled to the ferry to East Boston, made their way to the back of the ship and just waited for the right moment to discharge their bags. It never came. They were too exposed, and the boat was too crowded with people. Arriving in East Boston, they took a trolley to Orient Heights and rode it back again to the ferry. On their return on the ferry to Boston, they positioned themselves again at the rear and dropped the handbag and one suitcase into the water.

The last suitcase was another matter. It contained the torso of Susanna Geary. It was much heavier and cumbersome. Once back at Tremont Street to collect and then dispose of the trunk, they found a cab on Boylston Street

and asked to be taken to the Chelsea ferry. Once on board the ferry, they waited until it was midstream before heaving the suitcase overboard. The cab driver would later identify the two and confirm that he'd taken them out to Chelsea. He remembered them so well because they behaved so oddly, not allowing him to touch their luggage when he offered to help them with their heavy cargo.

The next day, the torso was discovered, and the two immediately skipped town, hiding out in New York City, where they were found by police and brought back to Boston to stand trial. Crawford immediately confessed, and with this information, the Boston Police were able to dredge the harbor in a more specific area to find the last bag containing Susanna's head. The handbag was retrieved by a diver on November 5 a short distance from the south slip on the East Boston side of the north ferry. Weighted with shot to keep it from floating, Susanna's head was wrapped in fabric from her own dress. The expression on her face was described as sheer agony—eyes wide open, hair disheveled.

A trial accusing Dr. McLeod, Crawford and Howard went on for the next few months. McLeod was acquitted. There was nothing in his background or character that would suggest that he would act in such a callous way. He was hailed as a hero of sorts, having been the doctor who tried in vain to save Susanna's life. As to dismembering her body, as a surgeon, he had the skills and knowledge, but he didn't have the equipment. Police never found the necessary surgical equipment in his office or elsewhere to pull off such a maneuver. McLeod was in the wrong place at the wrong time; he was an easy target for Howard and Crawford to blame.

Speaking of, both Howard and Crawford were found guilty of disposing of the dismembered body and served the maximum sentence of seven years at the Charlestown State Prison. It was never determined who exactly cut up Susanna's body. It was also never determined why anyone cut up Susanna's body, except to cover up her death. Certainly her abortion was illegal at the time, but there appeared to be at least an unspoken knowledge that these "delicate" types of operations occurred and that they were carried out at places like Mrs. Bishop's clinics. This may have been a case of some very hasty (and bad) decision making on the part of both Howard and Crawford.

After the trial was over in December, Susanna's body was finally released to the Geary family to be buried at the family plot in Leominster.

Chapter 10

MURDER AT THE Y

The Murder of Avis Linnell, 1911

Questions started to arise almost immediately after the events of October 14, 1911. The shock of Avis being found dead would never subside, but as her family, friends and, ultimately, law enforcement processed Avis's death, something wasn't quite right. Avis Linnell was as beautiful as she was talented. She was well liked. She had a loving family. What's more, she had plans for her life. Originally from Hyannis, Cape Cod, she was living at the YWCA on Warrenton Street while studying singing at the New England Conservatory of Music. She'd always had a beautiful singing voice, and her fiancé had convinced her to pursue her love of music. She was thrilled to be living in Boston, in love with her studies and even more in love with her handsome and charming betrothed, the Reverend Clarence Richeson. Suicide just didn't make sense.

The circumstances surrounding her apparent suicide didn't add up, either. Chief Inspector Joseph Dugan had suspicions immediately. Inspector Dugan had been around the block, and in his experience, women of Avis's class and status did not commit suicide with an intention to be found and identified quickly. A woman like Avis would have found herself a quiet, secluded place to do the deed. A woman like Avis wouldn't want to wind up as the subject of newspaper headlines; she wouldn't want to bring any attention to her family or to the state that brought her to her ultimate decision, because it would be too shameful. Seeking death in her room, in a building in which everyone knew her, in a town as big as Boston was so atypical that Dugan couldn't shake his doubts.

She also had a future to look forward to with her fiancé. But even that didn't quite square. After her housemates found out about the tragedy, they were able to reach him by telephone. His reaction to the news was odd—he was cool, unresponsive. He wouldn't address the media, afterward citing illness, not grief. He holed up at a home in the Chestnut Hill neighborhood of Brookline—a home owned by Moses Grant Edmands, the father of his *other* fiancée.

There was no question in the mind of Avis's brother-in-law that the Reverend Richeson should have come directly to the YWCA as soon as he heard the news. As McLean told the *Boston Globe*, "Why, he was supposed to be the best friend she had in the city….I would have acted more kindly toward a sick dog."

Other questions remained: if she didn't intend to kill herself, why take a lethal dose of cyanide? Perhaps she wasn't aware that she was taking poison. And if she wasn't aware of the danger, who'd given it to her and why? What was the motive? Chief Inspector Dugan was sure of one thing: if they ever found someone who'd given Avis Linnell an envelope of cyanide, that person would most certainly be found guilty of murder.

Piecing this puzzle together started in the usual place, with Avis's fiancé,

The handsome Reverend Clarence Virgil Richeson, Avis Linnell's two-timing betrothed. *Courtesy of the Library of Congress Prints and Photographs Division, Washington, D.C.*

the Reverend Richeson. Avis and Richeson met in her hometown of Hyannis. He was the pastor of her church, the Baptist church. She was only fifteen years old. He was charmed by her and started to visit her family at home. A year later, they were engaged to be married, and the date was set for October 1910. A year after that, she was dead.

Richeson, twelve years her senior, had had an adventurous life prior to settling in Massachusetts. He was born and raised in Virginia and attended school in Maryland before setting off to St. Louis to work as a motorman on the trolleys there. He joined the Baptist Church and determined that the life of a pastor was more his speed. He attended William Jewell

The Baptist church in Hyannis where Avis and the Reverend Richeson met. *Courtesy of the Library of Congress Prints and Photographs Division, Washington, D.C.*

College in Liberty, Missouri, in service of his religious education. Here he would engage in the two things that would dog him for the rest of his life: romance and trouble. He was expelled from school for cheating (on a test; the women would come later) but managed to sweet-talk his way back in, after taking a $700 "loan" from a young woman named Miss Patsey

Felts to help him along with his school work. After graduating, he became an itinerant preacher, traveling all over Missouri and Mississippi before moving to Massachusetts to attend the Newton Theological Seminary, where Patsey would again come to his aid by providing yet more money for his studies. Despite the distance between them, Patsey was confident that she would be repaid. After all, they'd been engaged since 1903.

Students attending the Newton seminary were given assignments to preach at churches in the eastern Massachusetts area. It was on one of Richeson's assignments at the Baptist church in Hyannis that he met Avis. He was instantly taken by her. She was a standout in the church choir and a youthful beauty. It should be said that a lot of the young women at church were smitten by their new young pastor. He was handsome and charming, had a warm and sonorous speaking voice and possessed a youthful vigor that was a rarity behind the pulpit. The two started to spend time together, and on her seventeenth birthday in 1908, he presented her with a gold engagement ring.

By all accounts, it was a love match. Her family loved him, and he doted on her. His career at the Hyannis Baptist Church, however, was not going as well. As much as the youngsters in the congregation liked his lively style of sermonizing, the elders found it to be "sensational," and not in a good way. In 1910, he resigned his position and soon found himself employed at the Immanuel Baptist Church in Cambridge. Shortly after, Avis began her studies at the New England Conservatory and waited for her wedding day, which was originally set for October 1910.

But something delayed their engagement—mainly, his engagement to another woman. Avis's family was shocked to read the announcement in the *Barnstable Patriot* in March 1911 that Richeson was engaged to be married to Miss Violet Edmands of Brookline, whom he had met soon after his arrival in Boston! Avis must have carried her hurt silently because there are no accounts of her heartbreak. Or maybe she was never heartbroken because she didn't really lose Richeson. By the time she returned to school in the fall of 1911, the romance was on again. The only reason she wasn't wearing an engagement ring was because he'd asked for it back to be cleaned. They spent an enormous amount of time together in Hyannis that summer and in Boston when school was back in session, but what Avis didn't realize was that Richeson was splitting his time between Hyannis and Brookline, sweet-talking both women.

In the interval preceding her supposed suicide, there was nothing notable about Avis's last days on earth. Her mother came to Boston on Wednesday to

The home where Avis grew up and was courted by Reverend Richeson in Hyannis. *Courtesy of the Library of Congress Prints and Photographs Division, Washington, D.C.*

spend some quality time with Avis, shopping and dining. When her mother went back to the Cape, Richeson was in Boston to fill Avis's social card. She and Richeson met for dinner on Friday evening and spent time together again on Saturday. After that day together, Avis went back to her room and slipped into her nightgown and robe. She drew a warm bath, placed her feet in it and ingested a powdered concoction. The next day, she was found nearly dead. She died in the hospital soon after, an apparent suicide.

The police may have chalked it up to a simple suicide if it weren't for Avis's brother-in-law raising questions about her death and for Inspector Dugan's own suspicions. An autopsy revealed that Avis was four months along in a "delicate condition," which might have been the motive for a suicide, but through a combination of smart detective work, the word of a trusted neighborhood druggist and a thorough investigation spanning the Eastern Seaboard and the midwestern United States, the truth willed out. While Avis was dying in the bathroom at her room at the YWCA, her dearly beloved was in Brookline sorting out invitations to his upcoming wedding to Miss Edmands.

Inspector Dugan was never fully satisfied with Reverend Richeson's innocence. His relationship to Avis and his strange reaction to her death

This photo shows George E. Cobb walking to the trial of Reverend Richeson. Cobb was the assistant clerk at the drugstore of William Hahn in Newton Centre, where Reverend Richeson bought cyanide to murder Avis Linnell. *Courtesy of the Library of Congress Prints and Photographs Division, Washington, D.C.*

were enough to put him at the top of the list of suspects. But still, Avis could have committed suicide as a jilted lover, and one who was pregnant to boot. Thankfully, William Hahn, a druggist at an apothecary in Newton Centre, came forward. He remembered meeting Richeson in the store one afternoon just days prior. Richeson came in to ask for the best drug to kill a pregnant dog. Hahn remembers giving him enough potassium cyanide to kill a kennel. Coincidence? Maybe, but it was enough to arrest Richeson on suspicion of murder.

Richeson was held at the Charles Street jail, pleading not guilty. But guilt must have weighed very heavily upon him. He attempted to commit suicide while awaiting trial, and by January, he was ready to confess to his crime. He asked for forgiveness. He asked for leniency. In January 1912, he got neither. He received the death sentence. For the next few months, Richeson's defense team tried to mount a case claiming that he was, in fact, insane. In a desperate attempt to save his life, attorneys were dispatched to his hometown to uncover rumored family members who also supposedly suffered from mental illness. No such connections were made, and Richeson was transferred to the "Death House" at the Charlestown State Prison, where he was electrocuted on May 21, 1912.

Just how many sighs of relief were breathed by his paramours after the news of his death? During Richeson's travels during his unsettled youth, he was engaged multiple times, leaving a trail of broken hearts, unkept promises—and at least one other potential murder victim. In 1904, while serving as a pastor in Kansas City, he took a shine to another young lady in the chorus and asked for her hand. She rejected his offer because she was too young. He then met a young widow to whom he became engaged, also in Kansas City. Richeson seemingly regretted his decision to ask the young widow to marry him and began to tell people that they were not engaged. You could have fooled her! She insisted that he was constantly telling her how much he loved her. The church where he was preaching decided that it could use a pastor with a little less attraction to drama and asked him to leave. He chose his farewell sermon as the time to make a statement about the ugliness of jealous women and told his congregation that he'd rather face a line of Gatling guns. While many in the crowd might have been confused by such a statement, the young widow's two brothers were not. When they arrived at his home to confront him and defend their sister, they found an empty room; Richeson had skipped town.

But what of Patsey Felts? Richeson led Patsey on from their engagement in 1903 until he was arrested for the murder of Avis Linnell. He wrote to her consistently throughout the years, sometimes more often than others, but always promising to reunite with her as soon as the opportunity presented itself. Because of some health issues, Patsey moved to Colorado and then on to Salt Lake City in an effort to convalesce. After learning about her health situation, Richeson told Patsey about a special powder "used in the East" that helped with weight gain and strengthening. Would she like some? Fortuitously for her, she never said "yes," or she might have been another victim of the Reverend Richeson's ruinous remedy.

Chapter 11

NEVERTHELESS, HE PERSISTED

William Monroe Trotter, 1914

William Monroe Trotter sat for a second time in a meeting with the president of the United States of America. Imagine, a black man meeting with the president of the United States, on seemingly equal terms. Not that Trotter was just any man; he was more than highly qualified to be going toe to toe with the president. Trotter was Harvard educated, the first black Phi Beta Kappa from the Ivy League university and the founding editor of a widely read newspaper called the *Guardian*. Nor was this just any meeting; Trotter and President Wilson were going to discuss the issue of racial equality in America and, more specifically, the issue of segregation in the federal government and White House. They had met over a year before, shortly after Wilson took office in 1913. That meeting went well enough, but it was no more than a formality. Still, Trotter was hopeful; in this second meeting, he was there to offer his counsel to the president on setting policy on issues important to African Americans in the United States.

During Woodrow Wilson's campaign, Wilson promised to "advance the interests of the race," prompting Trotter to put his reputation at stake to back him for president. The two of them had much to discuss in 1914. Any of the gains African Americans had made since Emancipation all seemed at risk, particularly in the South, where the number of lynchings of African Americans was growing unabated. Now it seemed as though President Wilson had no interest to make good on his campaign promise, which was a problem.

One such issue was the recent segregation of federal offices, particularly the U.S. Postal Service, which for many years had been one of the few places where both blacks and whites worked together and where blacks had a chance to advance their careers. Wilson also appointed whites to positions traditionally held by blacks, which were few and far between to begin with, and chose southern whites for other positions of power, which did not auger well.

Before their first meeting, Trotter worked with an association of race-related groups to coordinate a response to the White House. They gathered twenty thousand signatures on a petition objecting to the segregation of the White House and federal departments. Trotter raised money in Boston to fund a group that included Ida Wells-Barnett, a leading civil rights activist, to present the petition to Wilson in person in 1913, soon after Wilson took office. In that meeting, Wilson promised to investigate the staffing of offices, and in the intervening months, Trotter continued to press him on it. He wrote to the president several times over the coming months to continue their conversation, but he got no response. A year later, Trotter was finally able to schedule a follow-up meeting on November 12, 1914. This meeting didn't go as smoothly as the first. Wilson "explained" to the Trotter contingent that "segregation is not humiliating, but a benefit and ought to be so regarded by you gentlemen."

Trotter could not help himself and responded, "For fifty years white and colored clerks have worked together in peace and harmony.…Soon after your inauguration began, segregation was drastically reintroduced."

Wilson was taken aback by Trotter's "passionate" tone. Trotter continued to explain the betrayal he felt: "Two years ago, we thought you would be a second Abraham Lincoln." The back-and-forth gradually intensified for the next forty-five minutes. Ultimately, Wilson accused Trotter of political blackmail and abruptly cut the meeting short.

Trotter needed to be heard and would not back down, continuing to press his point. Wilson dug in his heels, in part because he was so insulted by Trotter's

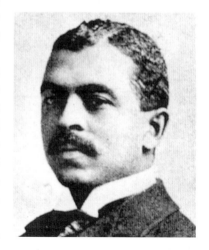

A portrait of William Monroe Trotter. *Courtesy of the Granger Historical Picture Archive.*

audacious behavior. After the meeting, Trotter reported to the press the disappointing content of the meeting. The next morning, the story was on the front page of every newspaper of the United States. The story was filled with drama—not only had a man, and a black man at that, directly confronted the president, but he got the president to admit that the segregation of the federal government wasn't just condoned but the supported policy of Wilson and his administration. This was a public affirmation of the acceptance of Jim Crow laws by the highest office in the United States.

While it wasn't the big win that Trotter was hoping for—in fact, it was the exact opposite—he did manage to maneuver himself and the issue of segregation into the national spotlight and to solidify his place as a leader in Boston's racial equality movement. He would also try, try, try again to contact Wilson on behalf of all African Americans in the United States, using this episode as a lesson—that is, if you can't move the leader of the free world, you can at least use the media to do some of the work for you.

William Monroe Trotter was born in 1872 in Ohio and raised in Boston's South End starting at the age of two. His father, James Trotter, had served in the Fifty-Fifth Regiment of the Massachusetts Volunteer Infantry of the United States Colored Troops. He was the first African American to achieve the rank of lieutenant and later agitated for equal pay between black and white soldiers. (Blacks received only half of what whites received.) Trotter may have been introduced to civil rights causes by the achievements of his father, who was the first black person hired by the U.S. Postal Service, a job he later quit when he was passed over for promotions time and time again. Because of his father's professional success, Trotter grew up fairly privileged. He attended Harvard, graduating with honors as the first black member of the Phi Beta Kappa chapter, with both undergraduate and master's degrees. It wasn't until he was in the workforce himself, forging ahead in the financial and then real estate fields without benefit of the breaks that his fellow Harvard classmates were getting, that his eyes were opened to racial inequality.

With his colleague George Washington Forbes and his wife, Geraldine (known familiarly as Deenie), he founded a weekly newspaper called the *Guardian*. In it, he covered police brutality against blacks, reported on the achievements of local African Americans and endorsed political candidates according to their views on race relations. He took special exception to the reports in white newspapers regarding black people's supposed role in criminal activity and sought to clear their names. At the same time, he would run stories of whites' crimes against blacks that were

William Monroe Trotter's home at 97 Sawyer Street in Dorchester. *Courtesy of the Historic American Buildings Survey of the Library of Congress.*

ignored in the mainstream press. The *Guardian*'s creation, however, had its roots in something a bit more controversial at the time—to denounce the teachings of educator Booker T. Washington. There were many modes of thought of how African Americans should go about working with whites to achieve racial equality. The idea getting the most support and traction at the time was one embodied by Booker T. Washington. Washington

believed that African Americans would find their lives improved by education and entrepreneurship, not in fighting against Jim Crow laws or for the right to vote. Trotter saw this as a short-sighted approach and thought that African Americans should take a more proactive tact—fight Jim Crow laws and fight against segregation. Trotter found Washington's views far too accommodating, calling Washington's "attitude…as one of servility." He became a major thorn in Washington's side.

Trotter was always willing to put his money where his mouth was. When Booker T. Washington came to Boston on July 30, 1903, to address a crowd at the AME Zion Church on Columbus Avenue, Trotter boldly questioned Washington and shouted him down and off the stage. There was so much confusion at the event that the police were called, which caused a near hysteria. Trotter and two others were arrested. Trotter served thirty days in the Charles Street Jail for his role in leading what the newspapers called the "Boston Riot."

Trotter was, in fact, best when causing "trouble." His strength was in organizing protests, mainly at Faneuil Hall. He was a born agitator. He seemed to enjoy taking on the role of David to many Goliaths. Sometimes it worked; often it didn't. One of his best-known efforts was to shut down the showing of D.W. Griffith's movie *Birth of a Nation* at the Tremont Theatre. The movie features a storyline that depicts African Americans (mainly played by white actors in black face) as simple-minded and sexually aggressive. It also treats the Ku Klux Klan as conquering heroes. Trotter mounted not only a community-organizing effort to peacefully protest the movie at the theater but a political effort as well. The movie needed to be deemed offensive by both the state and local governments before it could be closed down. He convinced the authorities that certain scenes should be removed for their violence and offensive portrayal of African Americans, but the film still played.

For his pièce de résistance, Trotter circled back to his old sparring buddy, President Wilson. This time, the year was 1919. Trotter recognized that World War I and its aftermath was a once-in-a lifetime opportunity to put the racial equality cause out in front of people around the world. Many African American soldiers had served in the war, and a few came back celebrated heroes. However, particularly in the South, this sacrifice was barely recognized and rarely honored. Lynchings of black men and women grew in number and brutality: for instance, a pregnant woman was beaten nearly to death before she was hanged, and even a decorated soldier was lynched for his insolence in "parading" around town in his army uniform.

With the segregation of the federal government and continued passing of Jim Crow laws, the future looked a whole lot less than promising for African Americans. Trotter saw this as a betrayal; if America had gone to war to save democracy, to ensure democracy and freedom from oppression for all, how could that not include African Americans at home?

As President Wilson prepared to make peace in Europe after the war ended, Trotter, along with other prominent African American leaders like Ida Wells-Barnett and W.E.B. Du Bois, wanted to make a case for racial equality as part of the peace package. None of them was granted a passport in time for the European journey, so Trotter went to plan B. He called himself "Will" Trotter (he normally went by Monroe) and stalked the docks on the waterfront of New York City, waiting to find a France-bound ship that would take him on as a chef. After days of waiting, he was on the high seas, putting his recently attained cooking skills to use and heading to Paris.

Once in Paris and after establishing himself, he tried desperately to meet with the powers that be to state his case. Letter after letter was met with no response. Learning from his previous experience, he went to the press. The Parisian newspapers loved him—and his message. He was interviewed almost daily and sent editorials to the papers for additional coverage. One such letter was a note directed to President Wilson, who'd just given a stirring speech regarding the fight against oppression and the sacrifices made on the battlefields during the war in the name of democracy. Empty words, thought Trotter, when lynchings of innocent African Americans happened almost daily at home with no chance for justice. For weeks he continued to live in Paris, calling for a clause in the treaty that would ensure full democracy for racial minorities, which became a cause célèbre. Despite the positive attention among Parisians, he got nowhere. The treaty was signed with no such language.

Trotter continued to press for language granting racial equality in the treaty, but it was never addressed. For years after, he continued to write and edit the *Guardian* and went on fighting the good fight, but he never achieved national prominence again. He was something of a lone wolf, always uncompromising to the point of losing allies and unable to maintain partnerships that may have strengthened his positions and his work.

On the night of his birthday on April 6, 1934, he spent the night as he normally would—pacing the roof of the building he rented a room in. Perhaps he was in deep thought and lost his footing. Perhaps he was disillusioned by the world and lack of progress made on behalf of his people.

We will never know. He was found the following morning dead on the ground. The newspapers called it a suicide.

Although one of the lesser-known leaders in the fight for racial equality, Boston has enshrined Trotter's name on an elementary school in Dorchester, and the University of Massachusetts formed the William Monroe Trotter Institute for the Study of Black Culture in 1984. In this way, his work and his memory persist.

Chapter 12

FATAL PLUNGE

Summer Street Trolley Disaster, 1916

James Carey, a wireworker in South Boston, was on his way home to Cambridge in the evening rush to celebrate his forty-fourth birthday with his wife and children. George Perkins, a twenty-eight-year-old Philadelphia transplant who quit his graduate work at Harvard to start his own boat-building business in South Boston, was also making his way home from work. James Crossland and Lewis Richards, both workers at the Commonwealth Fish Pier, were heading home to Medford. Bigge and Vincenzo Mecaluso usually left their toolmaking jobs at the Walworth Manufacturing Company with their brother John in tow, but on this day, John was getting caught up with a friend and had to take a later trolley home to East Boston. John got lucky. Unlike these six people, John lived to see another day. These commuters, along with forty others, lost their lives when the electric trolley they were taking from South Boston into downtown Boston catapulted from its tracks on the Summer Street Bridge and plunged into the cold waters of the Fort Point Channel.

On Tuesday, November 7, 1916, the talk of the town was the presidential election. Sitting president Woodrow Wilson was being challenged by former New York governor and Supreme Court justice Charles Evans Hughes in an extremely tight race. At stake was entry into war with Mexico and Germany. Because Hughes was in the lead, the riders were excited to get into downtown Boston to check on the latest election results. President Wilson eventually won by a scant twenty-three electoral votes.

Occupied by mundane thoughts of the election, birthday cake and dinner at home, no one was expecting anything more than the usual commute as they boarded car no. 393 in Southie. The trolley was motoring along at a nice clip, making its way from the P Street location of the Boston Elevated Railway carhouse, picking up a total of sixty-two passengers as it rattled along Broadway toward the Summer Street Bridge and downtown Boston. With only thirty-seven seats on board, sixty-two riders was considered a crowded car, with standing room only, although the trolleys could be packed with ninety or more. With sixty-two people on board, maybe the riders appreciated the fast pace the motorman, Gerald Walsh, was setting, since it could only get them to their destination faster and off that congested car.

Walsh picked up his last passenger roughly seventy-five feet from the foot of the Summer Street Bridge. He started to build some speed on the approach to the bridge, a retractile drawbridge that allowed ships to pass underneath. When the bridge was briefly closed to street traffic to accommodate a ship, a gate blocked traffic from taking a dive into the channel, and bright lights flashed in warning to slow down. Whether or not the lights were functioning that evening was later called into question, as Walsh cruised past the stop sign and toward the channel. The retractile bridge was drawn. The road was out, but Walsh caught it far too late. He braked hard, but the car had too much momentum. It blew through the gate and into the water.

Conductor George McKeon and Walsh were both in position to throw themselves out of the car before the trolley hurtled off the tracks and over the edge. Walsh was one of the first men rescued from the water, suffering cuts and bruises. An unidentified female passenger was also aware enough of what was happening to jump. She was apparently so "crazed by the closeness of death" that she picked herself up from the ground and ran.

According to eyewitness accounts, the car made an enormous splash, followed by an ominous gurgling sound that could be heard up and down the channel. The trolley quickly sank and settled thirty feet below on the muddy bed of the channel.

Most of the commuters were trapped inside, and very few escaped. When a handful of men broke through the surface of the water, they struggled to stay afloat. Hampered by their woolen overcoats and heavy shoes, they were quickly exhausted as they searched for a hand to save them. Luckily, there were a few boats nearby that hauled them out of the water to safety. The medical response was instant. Those plucked out of the water were immediately taken to a relief station at Haymarket Square.

The destroyed interior of Car 393. *Courtesy of the Francis A. Countway Library of Medicine.*

Some fifteen thousand people ran to the scene to watch in gruesome curiosity, while others waited anxiously to see if they knew anyone personally. Clergymen from nearby churches came as soon as they could to offer words of comfort to the living and supplications for the souls of the dead.

It soon became clear that there would be no more survivors. Rescue crews transitioned to recovery crews. By 7:00 p.m., roughly an hour and a half from the time that the trolley was lost, two bodies had been recovered by the firemen on the scene. They were identified by receipts found in their pockets. Called in at the request of Mayor James Michael Curley, the navy arrived, quickening the pace of the recovery. The navy was able to bring professional divers to the operation, as well as a tugboat with a crane. With strong search lights, the scene was lit up as bright as day.

Once the navy divers were able to access and assess the car, they put a plan in place to bring up the remaining bodies. The car was resting on the bottom of the channel "just as she would if she were still on the rails," all of its windows broken, all of the bodies in a jumble at the front of the car. Had rescue workers lifted the trolley up out of the water with the bodies inside, they may have fallen out with the movement of the trolley. It was decided to

Car 393 being hoisted up from the Fort Point Channel. *Courtesy of the Francis A. Countway Library of Medicine.*

bring the bodies out one by one. The first body was brought to the surface at ten o'clock. The divers worked all night long, collecting forty-four cadavers. Another man saved from the channel died later at City Hospital. Then there were the missing. Miss Elsa Woods, only nineteen years old, never arrived home in Roxbury that night after leaving her job at 10 L Street and did not return to work the next morning. After five days of searching, authorities admitted that her body was likely washed out to sea.

When the car was raised and taken for investigation to the power station of the Boston Elevated Railway Company in South Boston, the damage was devastating. The front vestibule, where the motorman would have been found had he not escaped, was crushed. The brake handle was twisted almost beyond recognition. The floor of the car was covered in evidence that at one time, only hours prior, it had been filled with hustling and bustling workers—hats, gloves, bags and even a bracelet were found.

Next would be an effort to figure out exactly what went wrong. A grand jury was called to hear testimony of eyewitnesses and expert witnesses alike.

Motorman Walsh claimed that the red warning lights indicating that the bridge was out were not lit. The bridge drawtender said without question that the lights were on. Walsh claimed that he did not see the gate that he crashed through was closed and that the brakes on the trolley did not work, but they did. They'd clamped so strongly to the trolley tracks that the rear of the trolley stayed attached to the tracks while the rest of the car broke free. Walsh was arrested for manslaughter and stood trial a year later. He was declared not guilty. He never drove a trolley again.

Chapter 13

NIGHTCLUB NIGHTMARE

The Collapse of the Pickwick Club, 1925

Rocco Carpato was in a daze. He'd somehow survived one of the worst catastrophes in Boston's history. He regained consciousness while being taken on a stretcher by medics to an ambulance and abruptly refused their care. Frantically, he went searching in the rubble for his friend. Reporters were already on the scene. They told him to check out the relief station that had just been hastily set up. He did, had a cut on his leg treated and then made his way back to the ruins. The only thing he found there was more confusion. He eventually found his friend and bandmate Billy Glennon, and the two made their way to the morgue at City Hospital. Rocco stayed there for two days, helping the coroner identify the dead. At first, he waited. But by the second day, the pace of the recovery quickened. Body after body was brought in, sometimes as many as three or four at a time. It was exhausting, but it was the least this singer and doorman could do. He knew how lucky he was. He said, "I was too close to tears myself to think how luckily, with God's help, I had escaped death." Later he would learn that another friend, club manager James Glennon, wasn't as lucky. The collapse killed a total of forty-five people.

During the early morning hours of July 4, 1925, the Pickwick Club was rocking. Revelers filled the club to get a head start celebrating the Fourth of July. The place was jam-packed, and the dance floor was humming. There was such energy in the room that at times it felt like the dance floor bounced along to the tune the Pickwick Club Orchestra was playing. As it turned out, it was.

It was nearing 3:00 a.m., time for bandleader Billy Glennon to prepare for the band's final song. Just before they started to play again, Rocco pointed out that the lights had just dimmed. Then they heard an odd sound, like water trickling down the walls. A porter looked at the two of them and pointed to a sand-like substance pouring from the ceiling and running down the walls. Was it an earthquake? They barely had time to make sense of what was happening before the lights cut off just as the ceiling and east wall of the club caved in. People started to flee in a panic, making their way toward Rocco, who was manning the door.

Dazed dancers stood on the floor, baffled by the cracking noise above them. Maybe they were firecrackers? It was the Fourth of July, after all. Then the floor gave way beneath them. Clifford Cusick was thrown to his knees but managed to grab onto a table, or maybe it was a chair, and pull himself along as the floor disappeared, piece by piece underneath him. His brother Buddy pulled him up and out the door, where he was piled on by more fighting to escape.

Anna McKee was at her post in the coat check room. She heard a rumbling and saw customers in a fuss. She thought that maybe a fight had broken out. But the swaying and swinging under her feet told her otherwise. She saw the ceiling start to fall, the crowd begin to run, she heard people crying out, but she was stuck in her place; like a horrible nightmare, she was stymied by fear.

The entire club was a pile of rubble in the time it took to snap your fingers.

The club could be found on the second floor of the Hotel Dreyfus, located at 6 Beach Street in Chinatown. It was a popular place. People were drawn to the club because of its bad-boy allure. Although the club operated on the up-and-up so far as anyone could prove, never selling liquor directly to the clientele—or at least being caught for it—it was known to be a safe haven for members of the underworld. Indeed, Lieutenant Inspector Benjamin Alexander, considered the best "pickpocket detective" in the country, was there that night on the hunt for a jewelry thief he'd been trailing for a week or more. Inspector Alexander lost his life that night.

The club was almost filled to capacity that evening, an estimated 175 enjoying the evening out. Because the guests were more boisterous than usual, the police had been called in to deal with a few disturbances that night. Good thing, too. As it happened, they were lucky to be in the right place at the right time. When the building crashed down, they came running. A fire alarm box was activated on Washington Street, so within minutes, more help was on the way. Patrolmen on the scene immediately started to pull people out of the rubble—two men stuck in a tangle of timber, a young woman

trying to get out by way of a ground-floor window. They lifted huge sections of floor to set people free.

Within fifteen minutes of the crash, flood lights were set up to illuminate the area, and soon after, the cries began. People who were buried alive started to scream out for help. The search and rescue began and would last for days. Rescuers did their best to find those in trouble and get to them fast. One was Mrs. Edith Jordan. The search crew heard her calls and spent nine hours tearing at the ruins to find her, speaking with her the entire time. She was able to describe the area she was in, that two men lay dead at her feet and that there were others close by. Mrs. Jordan was rushed to the hospital, where she died of her injuries only ten minutes after arriving.

Like Mrs. Jordan, many groups of men and women were found together. They'd been seated at the tables nearest the collapsed wall and ceiling and never had a chance to make it out alive. When search crews were finally able to reach that area of the wreckage, no one was found alive. Tables had been crushed flat; four men were found just like they sat around a table. The newspapers told of the gruesome finds the rescuers unearthed—a woman had been decapitated, another person cut nearly in two.

At the end of the block, a road block was set up to keep out onlookers, but people still gathered there. According to the newspapers, they were a solemn crew, keeping silent vigil over the proceedings, moving out of the way when the morgue truck came through. The crowd might perk up when they heard the cry, "Basket! Basket!" a call that indicated that another body had been found and needed to be carted away. On July 6, the total dead went from thirteen to thirty-six in the span of the day. The total number of victims when all was said and done was forty-five.

The building next door was evacuated in the event that it had suffered collateral damage. The other adjacent lot was empty.

No sooner had the wreckage been cleared of bodies than fingers started to point at who was to blame for the tragedy. Governor Fuller called for a full investigation, and immediately a grand jury was sent to view the ruins. The state commissioner of public safety gave a public statement calling the City of Boston fully responsible. The city inspector shot back that he'd recently inspected the building after a small fire in April and that the club was fit for occupancy. The two parties went back and forth, claiming that they'd done their jobs and were responsible for no more.

Twelve men were indicted for manslaughter. They included the city inspector, the supervisor of construction at the City of Boston, the contractor working at the vacant lot next door, the architect for the

proposed new building just getting underway on the vacant lot and the owner of the building the Pickwick Club occupied. There was plenty of blame to go around.

The city engineer, Hugh Urquhart, had inspected the property the day before the collapse. What he found was shocking; what he did was perhaps more shocking. He was there to inspect a new elevator at the five-story building. He had reason to go to the basement level and there found the piers of the building with large spans of space between them; the dirt, gravel and clay that should have been between them had been removed by crews prepping the adjacent lot for construction. What Urquhart did upon seeing this egregious negligence was—nothing. The manager of the Pickwick Club did nothing. The owner of the building did nothing.

However, the investigation was inconclusive as to whether the building foundation and walls actually needed the additional support. Experts testified that the strength of the piers, the makeup of the concrete and pressure of the remaining earth around the piers was more than enough to support the building. Between this finding and a lack of agreement as to which department at which agency in which government, state or city was ultimately responsible, all of the accused were found not guilty. A jury could not find clear evidence that any single individual had been "willfully, recklessly or wantonly negligent." And so, within months, the Pickwick Club tragedy faded into memory.

Chapter 14
SOARING SOCIAL WORKER

Amelia Earhart Takes Flight, 1928

The crowd was enormous. As she looked out at the sea of people, she was overwhelmed and humbled. All of these people had come out to East Boston Airfield just to see her and welcome her home to Boston. She was greeted by the mayor of Boston and modestly accepted a massive bouquet of flowers. For a brief moment in all of the excitement, she was able to reach out to her mother and sister for a hug, nearly crushing the flowers she held to her chest. It had been almost a month since she'd last seen them. When they found out where she had been and what she had done, they were at turns terrified, livid and ultimately relieved. Before she left without saying a thing, she had left them each a loving letter explaining her decision along with her last will and testament, in the event that she never returned. But they could all breathe a quick sigh of relief during their brief reunion before the tall, lanky social worker was escorted to a convertible Ford automobile and driven on a parade route through the streets of Boston.

An estimated 250,000 people came out to see her. Although she would admit that she had done nothing spectacular, calling herself nothing but "a sack of potatoes," that self-effacing attitude belied her courage, ambition and faith in new advancements in aviation. She may not have seen herself as much of a heroine, but symbolically, she represented a quantum leap in the advancement of women. She was aware of this, and in the future, she'd make sure to take advantage of every opportunity to come her way to ensure that women would have a role to play in the business and

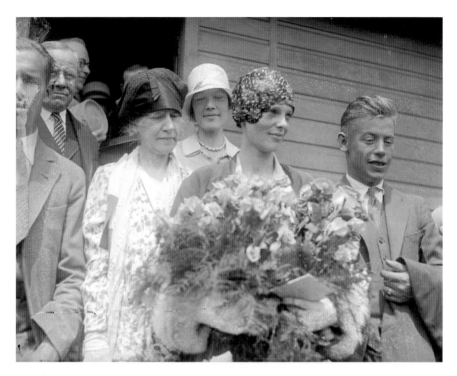

Amelia flanked by her mother and sister at her homecoming after her transatlantic flight. *Courtesy of the Boston Public Library, Leslie Jones Collection.*

development in the field of aviation, as well as seeing that her poor and luckless family would be taken care of. Although she intended to return to work at the settlement house in the South Cove neighborhood, a new life awaited her in New York City, around the world and in the air. Amelia Earhart the social worker had just become Amelia Earhart the first woman to fly across the Atlantic Ocean.

Amelia Earhart was born in 1897 in Atchison, Kansas, and spent much of her youth moving from place to place with her family. Her father found, and subsequently lost, work at various rail road companies, taking the family all over the Midwest, from Des Moines, Iowa; to St. Paul, Minnesota; Springfield, Missouri; and eventually Chicago, where Amelia graduated from high school.

From childhood, she aspired to have a real career and was aware of and interested in keeping tabs on women she found inspiring. She kept a scrapbook of articles about women who'd done remarkable things or achieved notoriety in their fields. From a young age, she had an inkling

that she wanted to be a self-supporting successful woman, although she didn't know the how or what of that equation. She may not have known exactly what she was going to do with the rest of her life, but she had high expectations and understood that she would need a quality education. That, however, would prove elusive. She was accepted to Smith College but opted instead to attend Columbia in New York. Her time there was short because she decided to rejoin her family in Long Beach, California, their latest address. While she kept her eye on educational possibilities on the East Coast, it was in California that she caught the flying bug. After taking an airplane ride at a local airfield, she immediately knew that she wanted to fly. She did all that she could, including working multiple jobs, to save up for flying lessons. Even better, her teacher was a female pilot, further solidifying her belief in the strength and power of women. After six months of lessons, she bought her own biplane that she nicknamed the Canary.

In 1924, it was time for another move. Amelia's mother was divorcing her father and decided to live closer to family in West Medford, a suburb of Boston. Amelia sold her biplane and decided to drive across the country with her mother in tow. Her car, again given a clever nickname, the Yellow Peril, must have made quite a scene—two women traveling solo in a bright yellow jalopy.

In Boston, she was as determined as ever to get back to her studies and enrolled again at Columbia. Sadly, within months, she was back in West Medford, too short on funds to continue. She was accepted at the Massachusetts Institute of Technology but never set foot on campus because she couldn't pay tuition. Amelia would have to abandon her dream of a higher education. Despite this sad state of affairs, she still yearned to make her own way and become her own woman. In fact, she did have one option many other women would have taken: the sure bet of an engagement and marriage.

While living with her family in California, she met a young man named Sam Chapman, a recent Tufts graduate working as an engineer. He was originally from Massachusetts; Amelia's family was certain it was a love match, and so was Sam. Amelia, however, wasn't so sure. Although they dated for several years and Sam made the move back to Boston with Amelia and her family, relocating to Marblehead, Amelia wasn't too warm on the concept of marriage, which she termed "being tied down." All the years that Amelia was trying to find her vocation in life, Sam stood by her, supportive in her need to make a mark before she settled down and certain that she'd come to him when she was ready.

In the meantime, she tried her hand at several different jobs, including nursing in Brookline and teaching English as a second language at a University of Massachusetts Extension School. Neither job enabled her to make ends meet, nor were they particularly fulfilling. On the edge of despair, looking down the barrel of her late twenties, she reached out for help. The Women's Educational and Industrial Union was there to answer the call.

The Women's Educational and Industrial Union (WEIU) was an organization established in 1877 to help women in a number of ways—a true resource for women, the first of its kind in the United States. The WEIU was a job training center for women that pushed beyond the typical employment avenues available at the time: teaching, nursing or housekeeping. It trained women in "salesmanship," which included purchasing and accounting, and provided a true entrée to the business world and a step up from the predictable retail counter. It also placed women in available jobs in the Boston area. Amelia, at that point desperate for a paycheck and ideally more meaningful work, applied to become a social worker at a local settlement house. Unsure of her qualifications, she may have exaggerated a little on her application, but no matter, her interviewer decided to take a flier in what she saw as a bright, "extremely interesting girl." Amelia got the job.

Settlement housing was a precursor to today's community centers and social service agencies. The people who worked in them would be considered social workers today. Settlement houses started to pop up in the United States in the late 1800s as immigration started to boom. More and more people of different cultures, speaking different languages, started to flood the cities along the East Coast and Midwest. They arrived in America to escape extreme poverty, lack of opportunity and even religious persecution. The Golden Land that they sought often didn't meet their expectations; living in cramped quarters in the most densely packed, unsafe and unsanitary neighborhoods was all they could afford until they found their footing.

Because of their sheer numbers, the arrival of immigrants could not be ignored by city authorities and the civic elite. Living in such unsanitary living conditions meant that the places immigrants occupied were often ground zero for outbreaks of cholera, tuberculosis or typhoid. The public health threat was real, but the ways to address it were misinformed; city officials and civic leaders blamed the immigrants instead of their substandard housing and plumbing and their absentee landlords. People also had a general ignorance of how disease spread; it wasn't through smells, called miasma, but the groundwater. And when sixteen people using one bathroom was a

commonality in the tenements in the North End and West End in Boston, groundwater contamination was a very real problem.

Another issue civic leaders were grappling with was how to assimilate so many newcomers, speaking so many different languages, with so many different cultural traditions. Many rejected the immigrants out of hand, accusing them of "dirty and nasty habits," seeing them as a lesser class of people. Others struggled with how to help them. It was out of the latter effort that the concept of settlement housing was born.

Pioneered in England and first brought to the United States by Jane Addams in 1889 when she founded the famous Hull House in Chicago, settlement housing brought services directly to the people in their own neighborhoods. Ideally seen as a way to build communities in neighborhoods where as many as fifteen languages were spoken and people were trapped in poverty, settlement houses offered English as a second language classes, citizenship classes and job training for adult women and men. Settlement housing had another agenda as well—that of assimilating newcomers in the ways of the American middle class. To that end, people could take in art, literature and travel lectures at a settlement house in addition to the other, more practical offerings.

Who staffed the settlement houses? Ever since their inception, it was a job that was most appealing to young people and, in particular, young women. Again, women had very few opportunities open to them to start a career, and the more educated women became, the more they were looking for opportunities to use their brains—and be paid for it. Settlement housing provided that opportunity to not only work but also be included in management and board leadership. Working in a settlement house offered a path not just to a job but to a career. Furthermore, like Jane Addams in Chicago, women started their own settlement homes, as Vida Scudder and Emily Greene Balch did in 1892, founding the Denison House.

Theirs was a slightly different concept. The Denison House was funded by a consortium of women's colleges that included Smith, Wellesley, Vassar and Bryn Mawr called the College Settlements Association. Located at 93 Tyler Street in what is today considered Chinatown but in Amelia's time was called the Bay Cove neighborhood, the neighborhood was a melting pot of Syrian, Chinese, Greek and Armenian immigrants. The Denison House offered classes to young and old, to men, women and families. By the time Amelia arrived in 1925, the settlement concept had changed little. Amelia started part time but quickly moved up to full-time work, making her mark by starting new clubs and activities for community members. She especially

made an impression on the children she worked with, taking them for rides in her jalopy, the Yellow Peril. She also made it possible for the young girls to have outdoor playtime in a playground usually only used by the boys. In every way, she quickly made herself indispensable. She was asked to serve on the board of the Denison House and attend national meetings of the Conference of the National Federation of Settlements. She thrived in her work. And she also made time to thrive in the skies.

New airfields were popping up all over the United States. A man named Harold Dennison (just a coincidence) founded the Dennison airfield in Quincy and quickly made Amelia's acquaintance as a fellow aviation enthusiast. He was so impressed by her knowledge and enthusiasm that he offered her a part-time job and a position on the new airfield's board of directors. At the airport's grand opening, she garnered the most attention as the youthful, attractive and *female* pilot.

While working at the Denison House, in her spare time Amelia wrote articles and was often a quotable resource for other writers, advocating for women to take to the skies. She sought out other female aviators and reached out to build an informal network among them. She continued to fly on weekends and holidays. All of these things culminated in what would be a life-changing event but at the time seemed only like a convenient, if fun, whim. To attract coverage of a fundraiser the Denison House was planning, the house director hired a biplane to drop leaflets over Boston advertising the event. She insisted that Amelia go along for the ride, sensing an excellent promotional opportunity. It worked. Amelia showed up in full aviatrix garb—leather bomber jacket (slept in for weeks to give it a lived-in appearance), goggles atop her head, her hair in a cute, short, curly 'do. The newspapers ate it up. Between this event and her work publicizing aviation for the Quincy airfield, what happened next shouldn't have surprised anyone.

In April 1928, Amelia got a phone call at the Denison House that she nearly ignored. A man on the other end had a once-in-a-lifetime opportunity to discuss: would she be interested in being the first woman to make a transatlantic flight? Her interest piqued to say the least, she was listening. She wouldn't get to fly the airplane (she'd only be a passenger), but a well-to-do philanthropist from Pittsburgh, also an avid flier (but forbidden by her horrified family to take on the flight herself, despite also being an accomplished pilot), was putting up the funding to ensure that a woman made a transatlantic flight. Amelia accepted, of course, and told the Denison House that she'd need some time off but that she'd be back to work by the end of the summer.

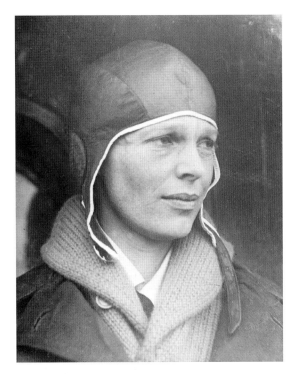

Amelia Earhart in her popular
and provocative flying gear.
*Courtesy of the Boston Public
Library, Leslie Jones Collection.*

She was partnered with two men—Bill Stultz, pilot and radio operator, and Slim Gordon, copilot and mechanic—to fly *The Friendship* from Boston to Newfoundland and then on to England. She was not permitted to do any actual flying but was given the title of commander and the "authority" to guide the flight in the event that there should be any question of "policy and procedure." An empty gesture to be sure, but it served to gin up more interest in Amelia as a pilot. She received no payment for her role in the flight but understood that if she survived it (and chances were really not on her side that she and her crewmates would), the opportunities ever after would more than compensate the lack of compensation.

By comparison, Stultz was paid $20,000 and Gordon $5,000. How's that for a wage gap?

Shrouded in secrecy, she told virtually no one of her upcoming trip. Only her director at Denison and her fiancé knew. Her mother and sister found out the day after Amelia left Boston, when they got a call from the *New York Times* asking for comment. After days of waiting for the perfect weather to take off, it finally arrived on June 3, 1928. Flying from East Boston, they encountered fog, bad weather and an unfortunate lack of laundry services on Newfoundland, where they were stranded for days

again awaiting clearer skies. When they finally took off, another female aviatrix was in pursuit, also trying to take the title of first female ever, but got socked in by fog at the last minute. Amelia and her copilots took off from Newfoundland on June 17, 1928, and again encountered more fog that set them off course. After a harrowing twenty hours and getting perilously close to running out of fuel, the trio landed in Wales. Not England, but close enough! The townspeople of Burry Point didn't know what hit them when the media flooded the town, excited to report on the miraculous flight.

Amelia's life was forever changed. The next few weeks brought a whirlwind tour that took her to London; New York for a ticker tape parade; back to Boston and a reunion with her family; and on to the Midwest. In each town, she was greeted not just as a celebrity but a true heroine. She was contracted to write a few articles about her experience for the *New York Times* and admitted that she wouldn't be able to return to the Denison House until she finished writing a book about her account of her travels.

The children of the Denison House welcome Amelia home after her courageous flight. *Courtesy of the Boston Public Library, Leslie Jones Collection.*

It was also obvious that she wouldn't return to her steadfast beau, Sam Chapman. She broke up with him in November 1928. He was forever brokenhearted.

As more writing, appearance and lecture opportunities popped up, with paychecks attached, it became clear that she would never return to the Denison House again, at least as a social worker. But she would never forget her friends there or the good work that they'd done together. Because her work as a social worker had ultimately sent her soaring.

Chapter 15

Monkeys and Cobras and Bears, Oh My!

The Zoo Shipwreck, 1938

The *Boston Globe*'s Thursday, April 21, 1938 edition breathlessly announced on its pages that a "Big Jungle Consignment" would be arriving on the freighter *City of Salisbury* in East Boston the next day. The article detailed the exotic cargo from Calcutta, India: three crates of deadly cobras, eight cages of rare birds, eleven crates of funky monkeys and sixteen huge pythons. Not only was the cargo exotic but potentially dangerous! The menagerie was set to arrive at Pier 4 in East Boston at 8:00 a.m. sharp. Unfortunately, the next morning's news would be just as excited but nowhere near as good. The next day, the ship packed with colorful and curious animals and other valuable and equally unusual items was impaled by an uncharted pinnacle of rock and would eventually split in two.

A perilous area between Nahant and the Boston Harbor, known as the Graves, has wreaked havoc on sailors and seamen alike since colonial times. First appearing on a chart drawn by Thomas Pound before 1700, there is some conjecture that the area was named after Thomas Graves, the vice admiral of John Winthrop's fleet. Others prefer the story that it is named for its fearsome features, dangerously hidden ledges and rock sitting just beneath the ocean's surface.

The concealed rocks weren't the problem for the *City of Salisbury*, at least not at first. The dense fog was to blame for the accident. After sailing from Calcutta, India, to Colombo, Sri Lanka, and then Halifax, Nova Scotia, the *City of Salisbury* was only a few miles away from its final destination. Fog enshrouded the coast from Maine to Boston. As it approached Boston

Harbor, the ship proceeded at half speed with a course set to listen for the Graves' whistle buoy. It never got within earshot. A lookout shouted that he saw breakers ahead. Harbor pilot William Lewis swung the wheel hard at full speed ahead to try to avoid the hidden ledge, but it was too little too late. They piled into the reef, getting speared in such a way that the ship pivoted there, the stern and bow hanging apart. The ship ground into the rocks with a grating sound and a sharp stop.

The ship immediately started to take on water. As the captain used the wireless to call for help, the fog was still so thick that even the light keeper at the Graves Light, less than a half mile away, couldn't see the wreck. The crew began the process of abandoning ship while Mehtab Dua, an Indian animal dealer and owner of the exotic animals, ran below deck to rescue three Himalayan bears and several cages of birds.

In short order, three towboats pulled alongside the ship, and the crew boarded. Later, the crates of snakes, birds and monkeys were also loaded up and taken to Pier 2 in East Boston. The crew was taken to the immigration station, also on the East Boston waterfront, while officers were taken to the Essex Hotel in Boston.

The next day, as news of the wreck made its way ashore, it became a curiosity for seagoing sightseers, who began to call it the Zoo Shipwreck. Even old-timers were amazed at the way the ship was pierced by the rocks, tearing it almost in half. The *Boston Globe* described the wreck as "ripped open like a tomato tin by a can opener." As if the stunning wreckage of the *City of Salisbury* and its sensational cargo weren't enough, even the crew dropped off at the immigration station was exotic in its own way. The ship hailed from India, and so, obviously, did its crew. Called "lascars," the Indian sailors wore fezzes or turbans and had dietary restrictions that flummoxed the staff at the immigration station, although they eventually made do with canned fish, potatoes, eggs and tea.

While the animals were rescued, much of the remaining cargo, worth an estimated $1 million, was not. Bales of hemp and chests of tea were seen bobbing in the ocean, on their way to being washed up on the shores of Winthrop, Cohasset and Hull. Months after the crash, residents of Hull were delighted to find live lobsters strewn along the shore and there for the taking. The savory salvage was taken home in buckets and stored in bathtubs until the time was right for "thermidors, newburgs and salads." Still, the owners tried to salvage what they could before the two pieces of the ship sank. Captain Owen Morris, who had stood by steadfastly and refused to leave the wreckage since the day of the disaster, directed the work. Sightseers

Above: The Zoo Ship cracked in two and sank. *Courtesy of the Boston Public Library, Leslie Jones Collection.*

Right: Bostonians were probably in awe at the lascars who manned the *City of Salisbury*. These men served on the *Viceroy of India*. *Courtesy of the Creative Commons.*

gathered along the shores of Nahant and Winthrop to view the goings-on. Longshoremen, paid twenty-seven dollars per day, risked their lives as the two halves of the ships teetered, every day getting closer to its final collapse. In roughly a week, working all day and through the night, 550 tons of cargo were safely deposited at Pier 4 in East Boston.

The animals were kept at Pier 2, where they were being cared for by Mr. Dua. According to the *Boston Globe* writer, the Indian birds called "thrushes" were thriving in their new home. Known for their ability to imitate the sounds and calls of other animals, "they chatter like monkeys, hiss like the cobras and moan like the bears. One cage of the thrushes is working diligently to imitate the whine of the tugboat whistles." A few monkeys died in captivity, while others broke loose later. Six monkeys were bought by the owner of an ice cream parlor in Salem, where they were displayed in a cage and apparently plotted their escape. At the appointed moment, the monkeys broke free and wreaked havoc on the inhabitants of the cities of Salem and Lynn. They stole cream from the top of milk bottles, dug up carrots, robbed apples and pears from trees and frightened children. Three were eventually captured, and two others were shot. And then there was one. The sixth was never found.

Later, it was confirmed that the captain and harbor pilot were not to blame for the wreck. The pinnacle that caused the disaster appeared on no official charts. The rock was, in fact, so narrow that it was more miraculous that the *Salisbury* hit it than not. And to have impaled the ship the way it did was truly a one-in-a-million chance. It is now called "Salisbury Rock" after the ship that discovered it in spectacular fashion, and the U.S. Coast and Geodetic Survey revised its charts immediately to include it.

By autumn, only the stern of the ship was visible, as the entire forward section had broken off and fallen into the ocean. Amazingly, the ship was left untouched by the destructive New England Hurricane of 1938, which caused an unprecedented amount of damage to the coast of New England. It was another lesser nor'easter that finally submerged the remains of the ship. The wreckage remains a favorite among diving and shipwreck enthusiasts to explore.

Chapter 16

JEW HUNTING

Anti-Semitism in Boston, 1943–1944

The train car of the El was packed on the afternoon of May 12, 1944. Traveling toward downtown Boston from the Ashmont station in Dorchester, the train was filled with reportedly two hundred people, mostly women, along with a few young men and at least one El guard, when all hell broke loose. As the train sped through Dorchester into South Boston, passengers were in a complete panic. Women screamed as they ducked swinging fists and fought to find a safe space amid the confusion. A massive brawl had started on one of the train cars, and the gang of twenty-three brutes who started it didn't care who got in the way of delivering a few punches to the three young men they went after. The three teens expected trouble but nothing like this—shouldn't they have been safe on the El in broad daylight, surrounded by women who could have been anyone's mother, grandmother or big sister? It was a shock that caught everyone completely off guard, prompting the El guard to pull the emergency cord to stop the train just before it would have arrived at Broadway station in South Boston, where it caught the attention of additional El personnel. Pulling into the station, the guard put himself between the three unfortunate kids and the mob that was attacking them, allowing them safe escape. All three were beaten badly, and at least one wound up in the hospital. They were the latest victims of a rampant and ugly anti-Semitism that held Boston in its grip for a decade.

Harold Rose, Eliot Lavin and Allen Stakowitz, all seventeen years of age, boarded the train after attending classes at the Dorchester High School for

Boys. A crowd of bullies followed the three and four more of their friends on a bus from the school to Ashmont station, where they all got on the El. A police car patrolling the area, on the lookout for exactly this kind of ethnically motivated violence, likely stopped the beating from happening before the kids got on the El, but it only postponed the inevitable. The seven Jewish boys knew to expect trouble but still weren't prepared for what happened. Once on the train, a group of twenty-three young rowdies with a vicious bent quickly divided the seven boys into two groups. Before Harold knew what was happening, he felt a sweater wrap around his face, blinding him, and Allen, who was standing, took a hard hit to the back of his head.

None of the Irish Catholic boys who delivered the beatings were ever caught or held accountable, but this event, like many other similar acts of harassment and intimidation, would finally result in a blue-ribbon panel appointed by the governor to crack down on the violence. The investigation would also unearth a disturbing truth—at least one police officer sworn to protect and uphold the law was guilty of being one of many officers who not only turned a blind eye to the violence but also participated in it.

While Boston's history is riddled with stories of anti–Irish Catholic sentiment and the revolting and violent behavior that accompanied it, little is widely known about this decade-long rash of anti-Semitism, which was particularly vile at a time when news of the Nazi extermination of Jews was shocking people around the world. If people had known that Jews were not safe on American soil in cities like Boston, they would have been shocked. Sadly, the events were underreported, until it was sussed out that while authorities weren't necessarily encouraging the behavior in Boston, by ignoring it, they were condoning it—and even in some cases participating in it.

When German Jewish immigrants arrived in Boston in the 1840s and Eastern European Jews started to settle in the 1880s, they were fleeing horrendous treatment. In Russia, the May Laws legislated large-scale discrimination—from legislating where Jews could and could not live, forbidding them mortgages, making their doing business impossible and limiting how many Jewish children could go to school to carrying out nighttime terror attacks on Jewish homes.

As Jews settled in Boston, like many immigrant groups before them, they moved to the North End, the West End and Chelsea. After a fire devastated their corner of Chelsea in 1908, leaving seventeen thousand homeless, they migrated to the Blue Hill Avenue and Grove Hall neighborhoods

of Roxbury and Dorchester. A small Jewish community had just started to bloom there after the congregation of the Adath Jeshurun synagogue moved to the Grove Hall area in 1900 and built a grand synagogue in 1905. Soon after in 1906, the Boston Elevated Street Railway extended its tracks from Grove Hall to Mattapan, opening the area for development that would naturally attract Jews, solidifying the location as a Jewish neighborhood well into the 1970s.

While violence against Jews was sadly not altogether unusual, in the years leading up to and during World War II, there was a nationwide growth of anti-Semitic violence in America and all over Europe that especially took hold in more ethnically homogeneous places like Boston, with its considerable population of Irish Catholics.

As people sought an explanation for the catastrophe of the Great Depression, the easy scapegoat commonly became the Jewish population, who were painted as unscrupulous, lying businessmen and bankers who had purposefully tanked the economy for their own gain. Later, as Europe lurched toward World War II, Jews were still looked upon as the cause of the world's ills. Rumors and misinformation proliferated as Jews were cast as evildoers trying to subvert the world order, trying to take over the

Father Coughlin giving a rousing speech. *Courtesy of the Boston Public Library, Leslie Jones Collection.*

government or, at the very least, trying to benefit from New Deal programs in the United States on the backs of those deemed more deserving.

Helping to spread these rumors and innuendo was a popular radio personality named Father Charles Coughlin. Known as the "Radio Priest," he had a voice and manner of speaking that was made for the popular radio programs of the late 1920s and 1930s. Anywhere between twenty and forty million listeners tuned into his radio broadcasts every Sunday, and many took every one of his words to heart. By the early 1930s, Father Coughlin had turned his attention to the political realm, sharing an isolationist and anti-Semitic worldview with his devoted listeners. He used his platform to exploit his listeners' fears about the fast-changing state of the world and spread conspiracy theories that fit his prejudiced opinion of the world. He started a voraciously anti-Semitic newspaper ironically called *Social Justice*. It was deemed so incendiary by Roosevelt's administration that its distribution through the U.S. mail was shut down by way of the Espionage and Sedition Act. Still, devoted readers found ways to subvert the mail and continue to read, distribute and spread Father Coughlin's words of hatred.

Father Coughlin delved further into the political realm, founding a national radical group called the Christian Front. The group started local chapters that helped to distribute *Social Justice*, organized and attended rallies with pro-Nazi speakers, boycotted Jewish businesses and systematically harassed the Jewish population. The Christian Front was particularly well organized and attended in New York City and Boston, two cities with large populations of poor Irish Catholics. Boston was so entranced by Father Coughlin that Mayor James Michael Curley, the mayor of Boston during the years of the Great Depression, boasted that Boston was the most "Coughlin-ite" of all major American cities and proudly hosted the Radio Priest when he visited Boston on a speaking tour.

It was partly because of how badly working-class Irish Catholics had historically been treated that made them identify so strongly by their ethnicity and religion. Political masters like John "Honey Fitz" Fitzgerald and James Michael Curley built careers out of such identification. By accentuating past ills and continuous snubs by the ruling Protestant class, Irish Catholics became more deeply entrenched in their "otherness." The Boston Irish character is an enduring one that can lend itself to a sense of cohesiveness, especially meaningful in tough times. However, the same sense of cohesiveness can backfire, creating a "them versus us" mentality, which was even stronger in the Depression and years preceding World War II. As the Boston Irish rose to political prominence in local politics

but were continuously locked out of statewide positions of power, business contacts and civic influence, the "them versus us" concept became a political strategy, as well as a self-fulfilling prophecy. Despite their local prominence, Boston Irish were still not accepted by the Brahmin powers that be.

When the Jews arrived in Boston, they also met resistance—they spoke a different language, came from an entirely different part of Europe (namely, Russia and Eastern Europe) and had vastly different cultural traditions than the local upper-crust British population, to say nothing about Catholic versus Protestant religious practices. Even still, they may have had more in common with Boston's aristocratic Brahmins than immediately met the eye. Their commitment to educational achievement, business building, community leadership, civic involvement and interest in progressive social justice issues might have made acceptance a bit easier in time.

Additionally, the Boston Irish political system effectively shut out the Jews on the local level; ward politics was set up to exclude them from being fairly represented, so they, in turn, tended to vote Republican, the party of the ruling Protestant class. All of these characteristics helped to ease a path for Jewish acceptance by the Boston Brahmins. They often worked with the Brahmin class on charitable causes and did business together. The Jews were naturally inclined to assimilate into the Brahmin culture and were discouraged from aligning themselves with the Irish Catholic structure of political power by virtue of their inaccessibility to ward politics.

The prevailing sentiments among the Irish Catholics about Jews were already tenuous. They were taught early in Sunday school that Jews were responsible for the death of Jesus Christ and could never be trusted. Combined with the "them versus us" mentality and encouraged by the vitriolic talk spread on the radio—talk that was pointedly not refuted by church leadership—Boston became a hotbed of anti-Semitic violence. Thus empowered and energized, an already disenfranchised group of people, Boston's Irish Catholics, no longer let their feelings fester. They were encouraged to take out their frustrations on the Jewish people in nearby neighborhoods. They called it "Jew hunting."

By 1944, Jewish organizations like the Anti-Defamation League of B'nai B'rith and the American Jewish Congress had been collecting affidavits of descriptions of beatings, harassment, property damage and cemetery desecration for more than five years. Of course, there were many more instances of violence that went unreported out of fear of revenge. It was so dangerous in Jewish neighborhoods that Girl Scout troops chose to stop

meeting in public. Synagogue windows were broken. A sixty-nine-year-old man was bashed in the head from behind while walking down the street. No one was ever caught. Over one hundred Jewish teenagers signed and sent Mayor Tobin a petition asking for help. It was never addressed. The newspapers ignored it. The police dismissed the harassment, fights and beatings as "kid stuff." The state political power structure chose not to pursue it.

At the time, Coughlin's group, the Christian Front, was highly organized in Boston. Their weekly meetings often crowded over five hundred people into the Hibernian Hall in the Roxbury neighborhood, roughly two

A vendor selling *Social Justice*, an anti-Semitic periodical published by Father Charles Coughlin, on the street in New York City. Photograph by Dorothea Lange, 1939. *Courtesy of the Granger Historical Picture Archive.*

and a half miles away from Grove Hall and Blue Hill Avenue, Jewish neighborhoods at the time. Our country was at war, but that didn't stop their leader, Francis Moran, from leading calls against President Roosevelt, calling him Roosenvelt, and arranging for the pro-Nazi propaganda film *Victory in the West* to be shown. As early as 1940, there was a call to the authorities for the Boston Christian Front group to be investigated for being associated with the New York City chapter that was plotting to overthrow the United States government. Governor Saltonstall refused, assured that the groups were not related.

Anti-Semitism was not limited to the hard-liners of the Christian Front. The traditional Evacuation Day celebration held on St. Patrick's Day (still a popular event for local politicians to attend today) hosted the outspoken anti-Semite Reverend Edward Lodge Curran, who publicly condemned the Jews as well as the British, our ally during the war. At the Evacuation Day ceremony in 1944, his words were so potent that they inspired a crowd of over one hundred men to riot during the annual St. Patrick's Day parade. Their rallying cry was to "get the dirty Jews!" Their main target was the Malden Veterans of Foreign Wars (VFW) Junior Band. In a classic show of machismo, the rioters decided to go after teenage band geeks as they made their way to a trolley waiting to take them home. The Malden teens, male and female, fought back as best they could. After being tripped up by the attackers, "pretty" Miss Barbara Marshall, nineteen, brought her trumpet down on the head of a "big fellow" as he tried to grab her. Salvatore Restuccia, sixteen, who was taken to the hospital for a possible broken jaw, testified that he'd seen brass knuckles. He was knocked out cold when he was yanked out of the trolley he was climbing into and hit on the head. Gerald LeBlanc was only fourteen years old; he suffered a black eye—and, later, nervous shock.

The focus of the mob's ire was Albert Cohen, a seventeen-year-old Jewish sailor who had recently been inducted into the navy. Albert was marching at the head of the Malden contingent and was spat on by a girl onlooker. When he passed, the ringleader of the rioters shouted, "They're not fussy who they get into uniform now; there's another Jew!" Bandleader Arthur Crosbie, a veteran of World War I, described the attack as "brutal." Miss Peggy Flanagan, who accompanied the junior band during its march and witnessed the attack, was in shock that no one of authority did anything to help the young people being attacked— the police, the El conductors and security and the Shore Patrol all stood idly by.

Jeremiah Lucey, a member of the Malden VFW, accompanied the band to the parade and testified to the nature of the attack. He said that they were "picking on Jewish members of the band. Our committee absolutely opposes hoodlumism and Nazism. It's on our doorstep now and we must face the facts."

The parade route was lined with Boston police officers, each spaced fifty feet apart. They did nothing. The Boston Police and city Public Celebration Committee later denied that the brawl had ever happened. Even the report in the *Daily Boston Globe* put the word *attack* in quotes, as though the term was an exaggeration. When Police Commissioner Sullivan finally did make a statement, it was only to clarify that "this bunch of young hoodlums was not from South Boston."

This episode, unfortunately, was not the straw that broke the camel's back. It was further evidence that there was a very big problem in Boston that hadn't been adequately addressed. Just six months prior to this horrifying event, something even more dangerous and insidious was exposed. On October 9, 1943, a police officer badly beat two Jewish teenagers while breaking up a fracas on Columbia Avenue in Dorchester. Four teenage boys were arrested, found guilty and then fined for their participation in the fight; all four of them were Jewish. No young men from the "other" group of boys fighting were arrested, just run off by the police. It was this miscarriage of justice that prompted a state-led investigation into anti-Semitic "hoodlumism" and Attorney General Bushnell to investigate the mismanagement of the Boston Police Department. It also prompted Governor Saltonstall to appoint a commission to investigate anti-Semitic crimes in Boston.

Ultimately, Attorney General Bushnell recommended that Police Commissioner Joseph F. Timilty be removed from his position, resulting in the appointment of Sullivan. Not much changed with the new crew in charge. There was some lip service done to address the street violence when some forty police officers and detectives were deployed to both Dorchester and Roxbury to patrol the streets there, but just a few months later, Commissioner Sullivan merely dismissed the attack on the Malden VFW Junior Band as nothing but "kid stuff."

Among the general populace, there was a very real fear that Boston could be teetering on the edge of Nazism. The journalist Wallace Stegner was so concerned that he wrote in a piece in the *Atlantic* about this possibility. Local rabbis agreed that the violence made them "fear for their people."

With the powers that be more comfortable ignoring the problem than really getting to the root of the issue, it was up to civic and community groups to take charge. Sixteen Protestant ministers met with the governor to discuss an outreach strategy to not only combat the overt violence being perpetrated against Jews but also to combat the more subtle anti-Semitic propaganda that was proliferating all across Boston. The Civil Liberties Union of Massachusetts reached out to Police Commissioner Sullivan to address the ongoing violence. The Boston School Committee met to discuss the teaching of tolerance and the "art of democratic living" in the public schools.

Jewish groups also responded by strengthening their core. They formed the Jewish Community Council of Metropolitan Boston, an umbrella group made up of the American Jewish Congress, the American Jewish Committee, the Jewish Labor Council and B'nai B'rith. Its mission was to more aggressively confront the anti-Semitic problem in Boston.

The Catholics were slow to come to the table. Cardinal O'Connell would not specifically renounce the violence on the streets of Boston, and Catholic participation was not strong on the interdenominational committees set up to address the issue. It wasn't until Cardinal O'Connell passed away and a new cardinal was appointed that the Church became more engaged. Many credit Cardinal Richard Cushing as the catalyst that finally brought change to the treatment of the Jews in Boston, bridging the gap between the Jewish and Irish Catholic communities both locally and across the world. A local boy who grew up in South Boston, Cushing's sister was married to a Jew, whom he called "the best Christian I know." He's credited with reaching out to those of the Jewish faith as none had ever done before. He was so active that in 1959, he was named Man of the Year by the *Jewish Advocate* of Boston. And from 1962 to 1965, he worked with the Second Vatican Council on adopting a policy that absolved Jews of the responsibility of the crucifixion of Jesus Christ.

Even with efforts like Cushing's, anti-Semitism did not disappear overnight in Boston. There was yet another spike of violence after World War II, in 1951 to 1952, that culminated in the beating murder of Rabbi Jacob Zuber in the Grove Hall neighborhood. The violence, while surprising in many ways, was short-lived, in part because the Boston community was now equipped with civic and religious groups and an accountable government to address it.

Chapter 17

THE TYLER STREET MASSACRE

Chinatown Murders, 1991

I t looks like a war scene," said an unnerved Mayor Flynn after being
called to the scene of one of the most horrific and bloody crimes in
Boston. Five men playing cards in a darkened gambling den were shot
point-blank in the head on January 12, 1991. According to an unlikely
survivor, all five had been begging for their lives. The brazenness of the
shooting was shocking, but what was more startling to the people of Boston
was that it took place in the quiet back alleys of Chinatown. Best known as
a bustling enclave popular for shopping in ethnic Asian markets and colorful
stalls along the streets or getting a late-night bite to eat, Chinatown had a
hidden dark side. There was a history of deep-rooted gangster activity long
entrenched in the neighborhood. Surprising to many, this was not the first
time that people were killed in cold blood on the streets of Chinatown.

It all started in 1903. A man wearing a shirt made of chainmail and
carrying a hatchet was caught fleeing the scene of a brutal murder on
Harrison Avenue. A man named Wong Yak Chong, a laundry owner in
Roslindale, was shot dead on the street; it was the first murder in Chinatown
in over twenty years. The chainmail-sporting assailant was sent by the leaders
of the On Leong tong to assassinate Wong Yak Chong and to warn others
in the Chinatown community which gang they all would need to answer to.
Chong was a member of the rival gang the Hip Sing, and On Leong had
just drawn a line in the sand.

The story is as old as time. A tong is, in its purest sense, a civic association
not unlike the VFW or the local neighborhood ethnic association. In its

literal sense, tong means "meeting hall" or "gathering place," a group set up to help recent immigrants settle in the community, find jobs and make business connections. Because Chinese immigrants were especially discriminated against, even by the police sworn to serve and protect, a tong would also provide protection from being cheated or taken advantage of. In fact, the police would very often blackmail illegal immigrants and make life hard for them by threatening to deport them, their family members and their friends. When it came to the police, Asian immigrants, even legal ones, were better off keeping their heads down and not reporting crimes. Instead, businessmen turned to the tongs for protection. Imagine, if you will, an ethnic chamber of commerce or, on the flip side, the mafia.

Just like their mobster brethren, some tongs got in the business of running gambling dens, selling drugs and prostitution. As the tongs grew, they started to compete and jockey for power. Belonging to one tong instead of another could put you at odds with a competing tong. Its methods of requiring loyalty were not unlike something you'd recognize from *Scarface*, except with hatchets and chainmail. The two tongs competing in Boston were the On Leong and the Hip Sing. Both tongs had long histories; On Leong was established in 1893 and Hip Sing in 1855 in New York City. The murder of Wong Yak Chong in 1903 started the first Tong War in Boston's Chinatown.

The police response to the murder of Wong Yak Chong was swift and brutal. They rounded up all Asian males of a certain age and demanded that they produce their registration papers. Three hundred men were arrested, and fifty were deported. The police crackdown settled things for a while in Boston, but it would only be a matter of time before more violence would explode on the streets.

While cities like San Francisco and New York City had much more active and violent Tong Wars, at times those wars bled into Boston. In 1907, the On Leong controlled most of Boston's Chinatown, confirmed by the killing of Wong Yak Chong. But the Hip Sing were eager to expand their empire and made their intentions known on August 2, 1907.

During the evening hours at Oxford Place, a popular alleyway hangout, firecrackers unexpectedly went off, creating a rush of confusion. Into the tumult charged several "hatchetmen" firing their guns at random into the crowd. When the smoke rose, three were dead and seven wounded. Called a "death orgy" by the press, both Boston and the nation were in a state of shock over the vicious nature of the crime. Again, the police responded quickly; nine men were arrested, three of whom were executed for murder. This time, it was the Hip Sing that struck. Gaining power and influence

and backed by more powerful leaders in New York City, the violent show of strength was meant to intimidate merchants to fall in line behind Hip Sing. It was one of Boston's few moments in the national spotlight, as greater problems abounded in New York and San Francisco. In time, crime in Boston's Chinatown would fade from the public eye, creeping back underground, where criminal tensions would percolate for more than eighty years, until they exploded again in 1991.

In the 1970s, a new kid arrived in Boston from Hong Kong named Stephen Tse. Tse joined the Chinese Freemason's Lodge, which had ties to the Hung Mun, China's oldest secret society. Tse was taken under the wing of the lodge's leader, Harry Mook, and it wasn't long before Tse needed to spread his own wings. By the 1980s, Tse had become the leader of the Ping On, which itself had ties to the old On Leong tong. Tse made connections selling heroin for the infamous Italian mobsters the Patriarca family, the leaders of the New England mafia. Tse had court officials and police officers on his payroll, paving the way for his rise to dominance in Chinatown. At his headquarters, the Ping On Club at 6 Tyler Street,

Boston Police responding to a murder of a Hip Sing member in Chinatown in 1930. The man was shot nine times. *Courtesy of the Boston Public Library, Leslie Jones Collection.*

Ping On Alley in Boston's Chinatown neighborhood. *Photo by Dina Vargo.*

he added gambling, prostitution and loan-sharking to his ever-growing business ventures. Though he lived in Quincy, he ruled over Chinatown, earning the name Sky Dragon.

In 1984, Tse went to federal prison for eighteen months, creating a vacuum of leadership. The Ping On tong fractured without Tse at the helm, making it possible for another gang to make a power grab.

A young, ruthless man from Saigon named Truang Chi Troung, known for his quick temper and bold robberies, took over the local gambling dens and expanded their reach from Chinatown into Canada. Employing dozens of Vietnamese men newly arrived in Boston, his show of power and control was more *Departed* than *Married to the Mob*. Complex heists, multiple murders, executions and an extortion ring all contributed to his empire, thought to value $1 million a year. Troung was eventually imprisoned when his backers turned on him for executing a rival crime boss. With at least three active gangs operating in Chinatown, there was more competition for money, power and, ultimately, loyalty. Events would eventually come to a gruesome conclusion in a back alley gambling den.

The entrance into Boston's Chinatown. *Photo by Dina Vargo.*

Yet another power broker was making a play in Chinatown—a protégé of Tse's named Hung Tien Pham. As Hung Tien Pham started to take ownership of a few gambling houses, he paid Tse to keep him in his good graces. He may have proved his loyalty to the Sky Dragon in one other way.

Word on the street was that a California-based gang was trying to go national. It had eyes on taking over Tse's Ping On and enlisted the help of a few locals. Dai Keung was in Boston ostensibly shaking down some of Tse's associates for an unpaid debt, but he was really testing the resolve of Tse's men and the mettle of Tse himself. When Dai Keung deliberately insulted Tse, Tse ordered Hung Tien Pham to go after him. In retaliation, Dai Keung was tracking Tse's movements, readying his own hit. He never got the chance.

On January 12, 1991, Dai Keung was playing mahjong with six other men, including the club manager, the "Wrinkled Skin Man." Three men

entered the gambling den, shouted "Robbery!" and made the men lie down on the floor. Moments later, they were all shot in the head, leaving behind a bloody and confusing scene. No money, jewelry or anything of value was taken. This was not a robbery gone bad—this was an execution. Although the targets were Dai Keung and the Wrinkled Skin Man, all the victims were shot in cold blood. The Wrinkled Skin Man was able to run away, and another man survived. Both were able to identify their attackers, who afterward made their way to New York City and then China. One of the three attackers, who has never been found, was Hung Tien Pham. The two others were extradited back to the United States and stood trial for the murders in 2005. Although steadfast in their claim of innocence, they were both found guilty and sentenced to life in prison.

BIBLIOGRAPHY

Albert, Michael R., MD; Kristen G. Ostheimer, MA; and Joel G. Bremen, MD, DTPH. "The Last Smallpox Epidemic in Boston and the Vaccination Controversy: 1901–1902." *New England Journal of Medicine* 344, no. 5 (February 1, 2001).

Berdick, Chris. "In the Shadow of the Dragon." *Boston Magazine*, April 2003.

Bradford, Charles H., MD. "Countway Happenings: Resurrectionists and Spunkers." *New England Journal of Medicine* 294, no. 24 (June 10, 1976).

Braude, Ann. *Radical Spirits: Spiritualism and Women's Rights in Nineteenth-Century America.* Bloomington: Indiana University Press, 2001.

Bull, Webster, and Martha Bull. *Something in the Ether: A Bi-Centennial History of Massachusetts General Hospital, 1811–2011.* Beverly, MA: Memoirs Unlimited, 2011.

Butler, Susan. *East to the Dawn: The Life of Amelia Earhart.* Boston: Da Capo Press, 2009.

Chirhart, Ann, and Betty Wood, eds. *Georgia Women: Their Lives and Times.* Vol. 1. Athens: University of Georgia Press, 2009.

Cogliano, Francis D. "Deliverance from Luxury: Pope's Day, Conflict and Consensus in Colonial Boston, 1745–1765." *Studies in Popular Culture* 15, no. 2 (1993): 15–28.

Cohen, Daniel A. "Passing the Torch: Boston Firemen, 'Tea Party' Patriots, and the Burning of the Charlestown Convent." *Journal of the Early Republic* 24, no. 4 (Winter 2004): 527–86.

Craft, William, and Ellen Craft. *Running a Thousand Miles for Freedom.* London: William Tweedie, 1860.

Dinnerstein, Leonard. *Anti-Semitism in America.* New York: Oxford University Press, 1994.

Electric Railway Journal. "Fatal Drawbridge Accident at Boston." 48, no. 20 (November 11, 1916): 1034.

Ford, Beverly, and Stephanie Schorow. *The Boston Mob Guide: Hit Men, Hoodlums and Hideouts.* Charleston, SC: The History Press, 2011.

Fox, Stephen R. *The Guardian of Boston: William Monroe Trotter.* New York: Atheneum, 1970.

Gamm, Gerald. *Urban Exodus: Why the Jews Left Boston and the Catholics Stayed.* Cambridge, MA: Harvard University Press, 1999.

Hagedorn, Ann. *Savage Peace: Hope and Fear in America 1919.* New York: Simon and Schuster, 2007.

Harrison, William. "Phylon Profile IX: William Monroe Trotter—Fighter." *Phylon* (Clark Atlanta University) 7, no. 3 (third quarter 1946).

Harvey, John. *Photography and Spirit.* Chicago: University of Chicago Press, 2007.

Hassett, George. *Gangsters of Boston.* Rock Hill, SC: Strategic Media Books, 2013.

Heglar, Charles J. *Rethinking the Slave Narrative: Slave Marriage and the Narratives of Henry Bibb and Ellen Craft.* Westport, CT: Greenwood Press, 2001.

Henderson, D.A., MD. *Smallpox: The Death of a Disease.* Amherst, NY: Prometheus Books, 2009.

Iserson, Kenneth V., MD. *Death to Dust: What Happens to Dead Bodies.* Tucson, AZ: Galen Press, LTD, 1994.

Kaplan, Louis. *The Strange Case of William Mumler, Spirit Photographer.* Minneapolis: University of Minnesota Press, 2008.

———. "Where the Paranoid Meets the Paranormal: Speculations in Spirit Photography." *Art Journal* 62, no. 3 (Autumn 2003).

Keller, Corey, ed. *Brought to Light: Photography and the Invisible, 1840–1900.* San Francisco: San Francisco Museum of Art, 2008.

Koplow, David. *Smallpox: The Fight to Eradicate a Global Scourge.* Berkeley: University of California Press, 2003.

Lause, Mark A. *Free Spirits: Spiritualism, Republicanism, and Radicalism in the Civil War Era.* Champaign: University of Illinois Press, 2016.

Lehr, Dick. *The Birth of a Nation: How a Legendary Filmmaker and a Crusading Editor Reignited America's Civil War.* New York: Public Affairs, 2014.

Levine, Hillel, and Lawrence Harmon. *The Death of an American Jewish Community: A Tragedy of Good Intentions.* New York: Macmillan, 1992.

Lovell, Mary S. *The Sound of Wings: The Life of Amelia Earhart*. New York: St. Martin's Press, 1989.

Lukas, J. Anthony. *Common Ground: A Turbulent Decade in the Lives of Three American Families*. New York: Vintage Books, 1985.

Mariner, Wendy K., JD, LLM, MPH; George J. Annas, JD, MPH; and Leonard H. Glantz, JD. "Jacobson v. Massachusetts: It's Not Your Great-Great-Grandfather's Public Health Law." *American Journal of Public Health* 95, no. 4 (April 2005).

McCaskill, Barbara. *Love, Liberation and Escaping Slavery: William and Ellen Craft in Cultural Memory*. Athens: University of Georgia Press, 2015.

McConnville, Brendan. *The King's Three Faces: The Rise and Fall of Royal America, 1688–1776*. Chapel Hill: University of North Carolina Press, 2006.

Menting, Ann Marie. "Midnight Plunder." *Harvard Medical Alumni Bulletin* 82, no. 3 (Autumn 2009).

Mikal, Alan. *Exploring Boston Harbor in Photographs and Text*. North Quincy, MA: Christopher Publishing House, 1973.

Montillo, Roseanne. *The Wilderness of Ruin: A Tale of Madness, Fire and the Hunt for America's Youngest Serial Killer*. New York: William Morrow, 2015.

Natale, Simone. *Supernatural Entertainments: Victorian Spiritualism and the Rise of Modern Media Culture*. University Park, PA: University of Penn State Press, 2016.

Norwood, Stephen H. "Marauding Youth and the Christian Front: Antisemitic Violence in Boston and New York During World War II." *American Jewish History* 91 no. 2 (June 2003).

Puttkammer, Charles W., and Ruth Worthy. "William Monroe Trotter, 1872–1934." *Journal of Negro History* 43, no. 4 (October 1958).

Richardson, Sarah. "The Man Who Fought the Klan." *American History*, n.d.

Rich, Doris L. *Amelia Earhart: A Biography*. Washington, D.C.: Smithsonian Institution Press, 1989.

Roach, Mary. *Spook: Science Tackles the Afterlife*. New York: W.W. Norton and Company, 2006.

———. *Stiff: The Curious Lives of Cadavers*. New York: W.W. Norton and Company, 2003.

Schneider, Mark R. *Boston Confronts Jim Crow*. Boston: Northeastern University Press, 1997.

Snow, Edward Rowe. *The Islands of Boston Harbor: 1630–1971*. New York: Dodd, Mead & Co., 1971.

———. *Marine Mysteries and Dramatic Disasters of New England*. New York: Dodd, Mead & Co., 1976.

Stack, John F., Jr. *International Conflict in an American City: Boston's Irish, Italians and Jews, 1935–1944*. Westport, CT: Greenwood Press, 1979.

Stegner, Wallace. "Who Persecutes Boston?" *The Atlantic*, July 1944.

Sterling, Dorothy. *Black Foremothers*. New York: Feminist Press at the City University of New York, 1988.

Waite, Frederick, C., PhD. "An Episode in Massachusetts in 1818 Related to the Teaching of Anatomy." *New England Journal of Medicine* 220, no. 6 (February 9, 1939).

Warren, Edward. *The Life of John Collins Warren M.D. Compiled Chiefly from His Autobiography and Journals*. Boston: Ticknor and Fields, 1860.

Willrich, Michael. *Pox: An American History*. New York: Penguin History of American Life, 2011.

Winters, Kathleen C. *Amelia Earhart: The Turbulent Life of an American Icon*. New York: Palgrave MacMillian, 2010.

Newspaper Citations

Boston Daily Globe. "Avis Linnell Not a Suicide." October 18, 1911, 1.

———. "Barely Ten Are Saved." November 8, 1916, 1.

———. "Believes It Is Not a Mistake." October 21, 1911, 6.

———. "Boston 'Front' Absolved of Part in Plot." January 16, 1940, 2.

———. "Car Victims Are All Identified." November 9, 1916, 1.

———. "Civil Liberties Union Scores Anti-Semitism in Letter to Sullivan." May 27, 1944, 3.

———. "Dancers in Wall's Path Says Club's Check Girl: Anna Mckee, Injured." July 5, 1925, A19.

———. "Dr. Mcleod's Arrest Causes Sensation." November 4, 1905, 1.

———. "'Evidence of Brutal, Unprovoked Assault by Police Sergeant,' Says Attorney General." November 19, 1943, 21.

———. "40 Detectives Join Police Here in Search of Racial Hoodlums." October 21, 1943, 1.

———. "Girl Killed to Seal Lips." October 19, 1911, 1.

———. "Girl's Head Recovered: Found Close to the Ferry Slip." November 6, 1905, 1.

———. "Lay Wreck to Uncharted Rock." April 26, 1938, 1.

———. "Leaping of Dancers Caused Collapse." July 6, 1925, A11.

———. "Little Light on Winthrop Mystery." September 23, 1905, 1.

————. "Loyal Wife's Joy Unbounded: Dr Mcleod, Acquitted, Leaves Court Room." December 3, 1905, 17.

————. "Mayor Early on the Scene: Takes Charge of Situation at Fatal Bridge Accident." November 8, 1916, 9.

————. "Mcleod Jury Seals Verdict: Finding Returned At 10:15 Last Night." December 2, 1905, 1.

————. "Mrs. Geary's Belief Shaken: Not Positive That Daughter Was Suit Case." November 1, 1905, 1.

————. "Night of Horror in Hunt for Bodies: Workers Toil Frantically in Chill." July 6, 1925, 1.

————. "'Not Guilty' Says Pickwick Jury." August 13, 1925, 1.

————. "Only One Monkey Left of Shipwreck Survivors." August 29, 1938, 13.

————. "Pick Wick Club Lure Lay in Its Mystery." July 5, 1925, A18.

————. "Pickwick Crash Accused Now 10: Seven More Arraigned after Indictment." July 14, 1925, 1.

————. "Police Loss in Crash Heavy." July 6, 1925, 11.

————. "Port of Boston: Big Jungle Consignment Arriving Tomorrow." April 21, 1938, 11.

————. "Protestant Clergy to War on Hub's Jewish Attackers." April 28, 1944, 12.

————. "Race against Time and Sea: Gang Salvaging Cargo." April 25, 1938, 1.

————. "Richeson Cool When Charged with Murder." October 21, 1911, 1.

————. "Richeson Goes Calmly to His Death in Chair." May 21, 1912, 1.

————. "'Salisbury Rock,' Hidden Cause of Wreck, Put on Chart." April 27, 1938, 1.

————. "Says Club Piers Lacked Support." July 8, 1925, 1.

————. "Says Mcleod Made Plans: Crawford Testifies in Suit Case Trial." November 28, 1905, 1.

————. "School Committee Conference Urges Fight on Anti-Semitism." December 21, 1943, 6.

————. "State Police Enter Probe of Racial Hoodlumism." October 20, 1943, 1.

————. "Survivors' Stories of Building Horror: Saw Friends Trapped." July 5, 1925, A20.

————. "Think He Has Not Told All: Susanna Agnes Geary, the Suit Case Victim." October 31, 1905, 1.

————. "Third Expert Backs Others: Lack of Shoring Again Blamed for Collapse." August 7, 1925, 3.

————. "35 Victims Identified—Grand Jury Begins Investigation Today." July 6, 1925, 1.

————. "Timilty Hits Back as Bushnell Raps Police, Clears Boys." November 19, 1943, 20.

————. "Trying Ordeal for Mrs. Geary: She and Daughters See Susanna's Head." November 7, 1905, 1.

————. "Turn Searchlight on Pickwick Club Tragedy." July 7, 1925, 1.

————. "12 Bodies Taken from Pickwick Club Ruins." July 5, 1925, A1.

————. "20 Mates Beat Three Jewish Boys, Clergymen Demand End to Anti-Semitism." May 13, 1944, 1.

————. "Two Arrests Clear Suit Case Mystery: William Howard Confesses." November 3, 1905, 1.

————. "Worked Night and Day at Morgue Identifying Bodies." July 7, 1925, 9.

————. "Wreck Poised at Mercy of Tides: Where Eight Men Leaped to Safety Ship Breaks, Eight Escape Leap Over Crevice as Bow Drops Cargo Scattered over Water." April 24, 1938, B1.

Carberry, John W. "Richeson's Most Faithful Friend." *Boston Daily Globe*, January 14, 1912, 1.

Mutrie, Joseph. "Animals Safe; Seas Pound Ship: Rich Cargo Is Ruined by Grounding in Fog City of Salisbury Crew Safe but Vessel Is in Danger on Graves Light Shoals." *Daily Boston Globe*, April 23, 1938, 1.

Nashua Telegraph. "Trolley Car Victims Buried." November 11, 1916, 7.